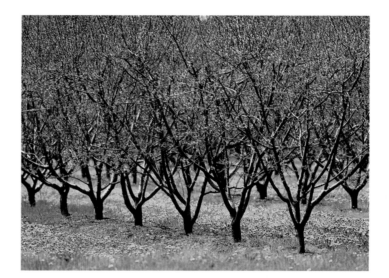

NIAGARA

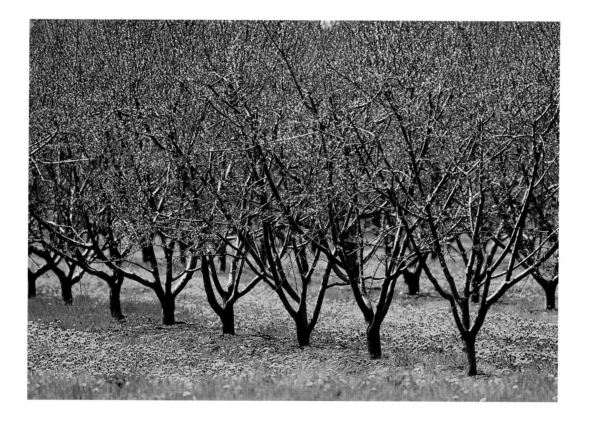

WHITECAP BOOKS
VANCOUVER / TORONTO / NEW YORK

Text by Tanya Lloyd
Edited by Elizabeth McLean
Photo editing by Tanya Lloyd
Proofread by Kathy Evans
Cover and interior design by Steve Penner
Desktop publishing by Susan Greenshields
Printed and bound in Canada

Canadian Cataloguing in Publication Data

Lloyd, Tanya, 1973–

 Niagara

 ISBN 1-55285-019-6

 1. Niagara Peninsula (Ont.)—Pictorial works. I. Title.
FC3095.N5L56 2000 971.3'3804'0222 C00-910060-1
F1059.N5L56 2000

The publisher acknowledges the support of the Canada Council and the Cultural Services Branch of the Government of British Columbia in making this publication possible. We acknowledge the financial support of the Government of Canada through the Book Publishing Industry Development Program for our publishing activities.

For more information on the Canada Series and other Whitecap Books titles, please visit our web site at www.whitecap.ca.

Visitors flock to the thundering falls, tour the area wineries, and stroll through the lush summer gardens. In the midst of these crowds, it is easy to forget that the Niagara region—and one courageous resident—once played a pivotal role in the existence of Canada. As the United States gained independence from Britain, thousands who stood behind the British crown flocked to Canada. Among these Loyalists was a 20-year-old woman destined to become one of the country's most famous heroic figures.

Laura Secord lived in a modest home in Queenston with her husband and their eight children. When American soldiers arrived at the door in June 1813, she was forced to offer them food and lodging. The War of 1812 between the British and the Americans was at its height. The Americans had invaded from Detroit in July 1812 and burned the British fort at York in April 1813. The family had no choice but to allow the soldiers into their home.

As Laura Secord served the feasting and drinking soldiers, they began to boast of how they would attack the British at Beaver Dams, taking them by surprise and gaining control of the Niagara Peninsula. Laura overheard their talk and knew that the British fort must be warned. Because her husband had been wounded in battle, she set off alone before dawn, avoiding the main roads and travelling a 32-kilometre (20-mile) route from her home. According to popular legend, she took a cow and a milk bucket for disguise.

Laura toiled for hours through the wetlands and swamps of the peninsula; finally she reached the fort and delivered her warning. Only two days later, the British forces ambushed the American soldiers, ending their attack. Upper Canada was safe.

In the last two centuries, the region has boomed. Farmers export agricultural products around the world, winemakers compete on an international scale, and 14 million visitors each year flock to see the famous falls. Some of these sightseers stop to tour the home of Laura Secord, and discover the tumultuous past of the Niagara Peninsula.

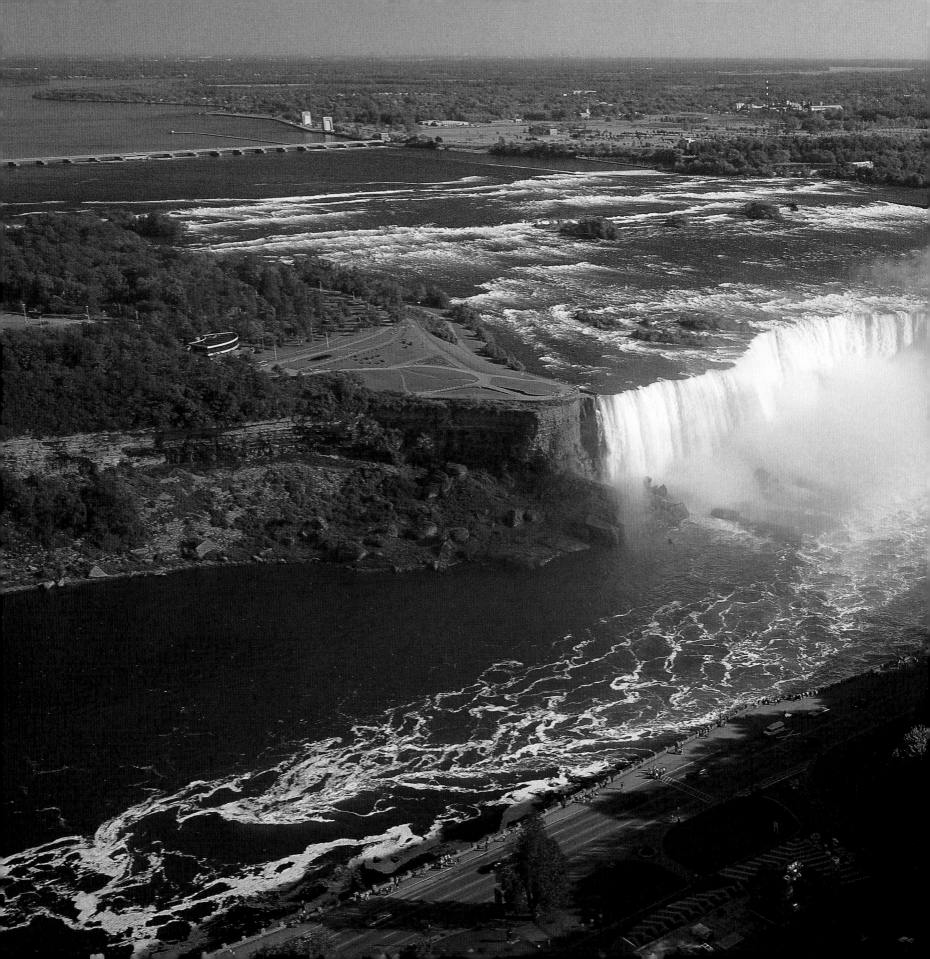

Niagara Falls drains a vast area of Ontario: 683,800 square kilometres (264,000 square miles), including four of the Great Lakes.

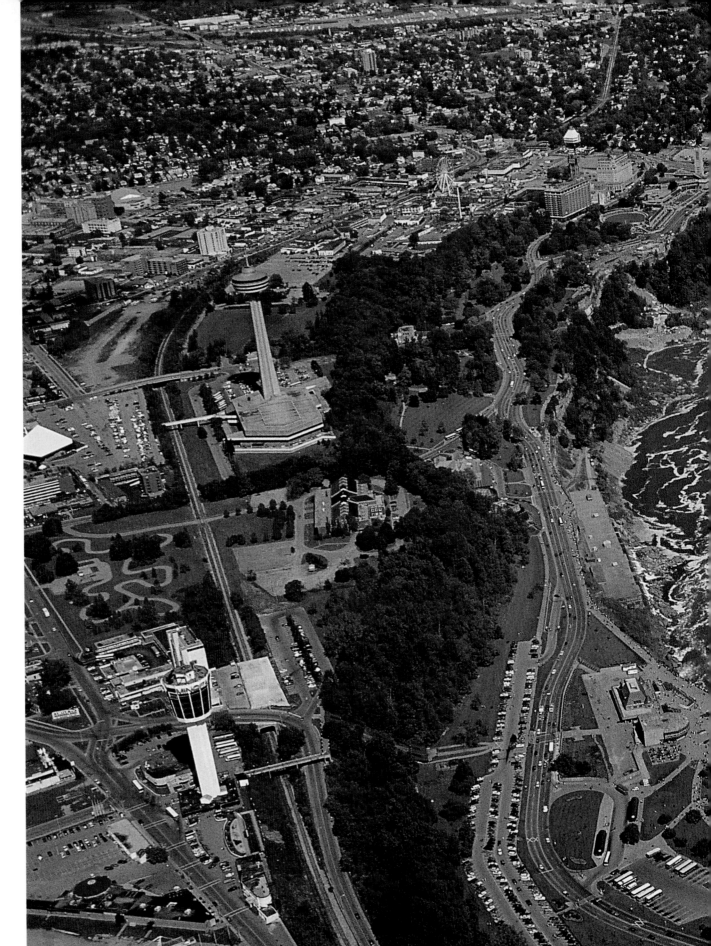

At 56 metres (185 feet), the American falls are slightly higher than the Horseshoe Falls on the Canadian side of the border. The soft rock beneath the water is constantly eroding, and scientists predict that, centuries from now, the falls will become a series of rapids.

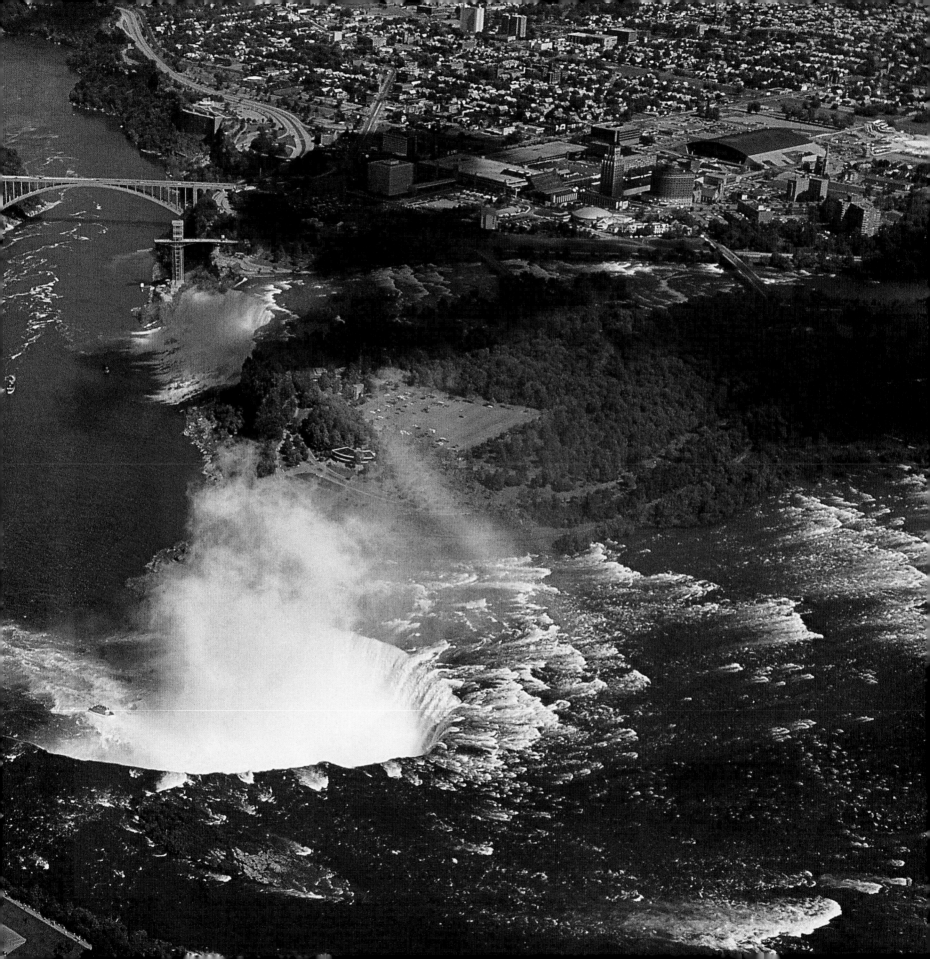

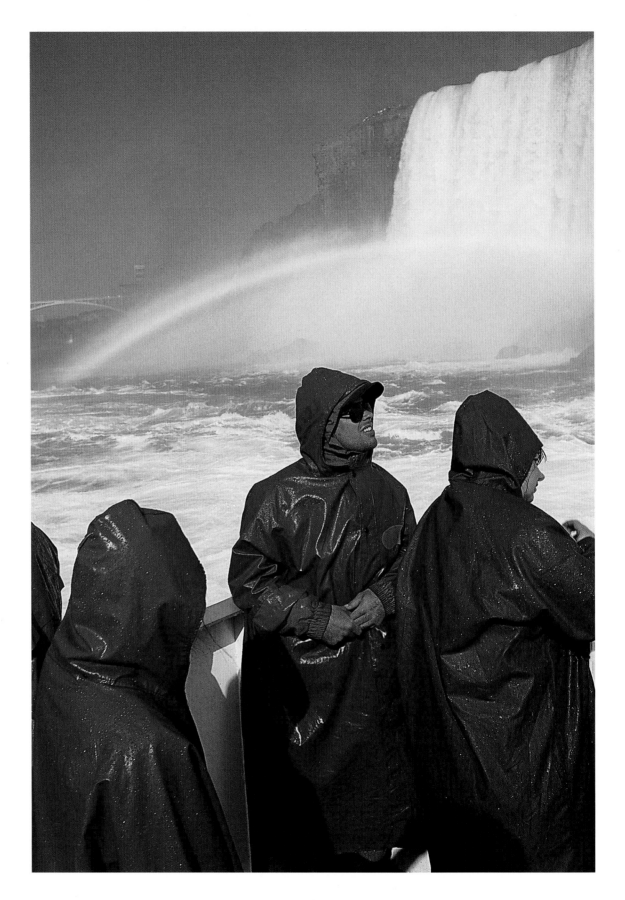

Clad in raincoats, passengers ride the *Maid of the Mist* on a journey to the base of the falls. The vessel ventures closer and closer, until spray coats the visitors and the thunder of the water is deafening.

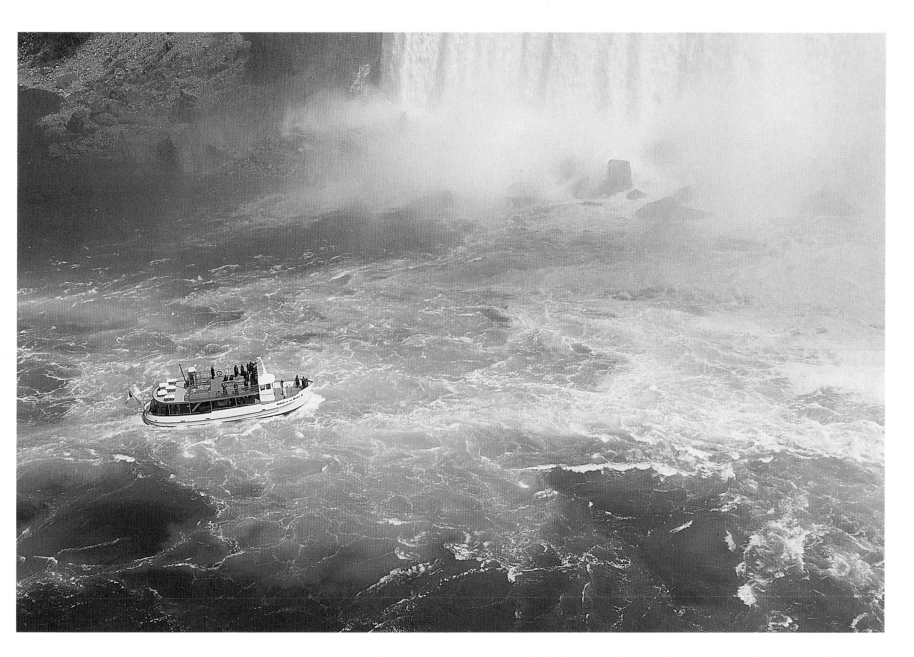

For more than 150 years, *Maid of the Mist* boats have carried eager sightseers to the base of Niagara Falls. In 1960, one of the boat captains noticed an orange life jacket in the water and rescued seven-year-old Roger Woodward, the first person to survive a trip over the falls with no protection.

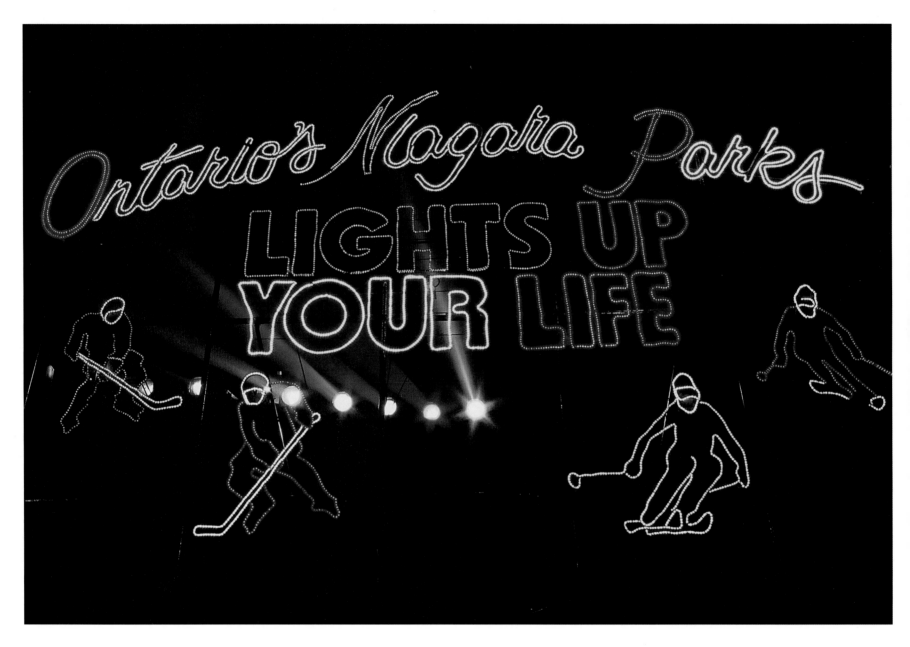

The Winter Festival of Lights is held from November to January each year. An illuminated night parade winds through Queen Victoria Park, fireworks light up the sky above the falls, and renowned musicians entertain the crowds.

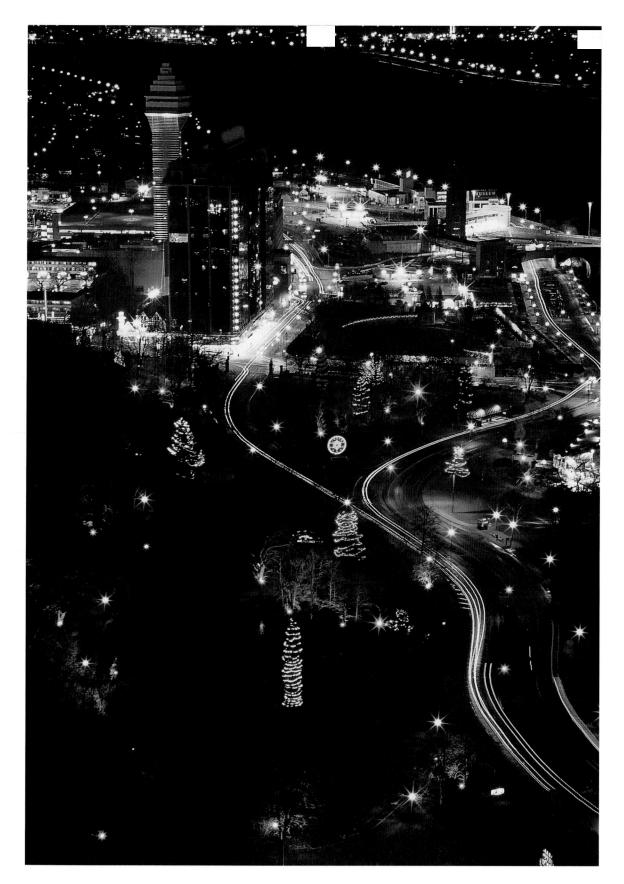

The largest light festival in Canada, the Winter Festival of Lights was first held in 1982. There are now over 50 light displays throughout the city.

Ice turns the American side of Niagara Falls into a winter wonderland. In 1848, millions of tonnes (tons) of ice from Lake Erie blocked the river and actually stopped the falls completely for 30 hours.

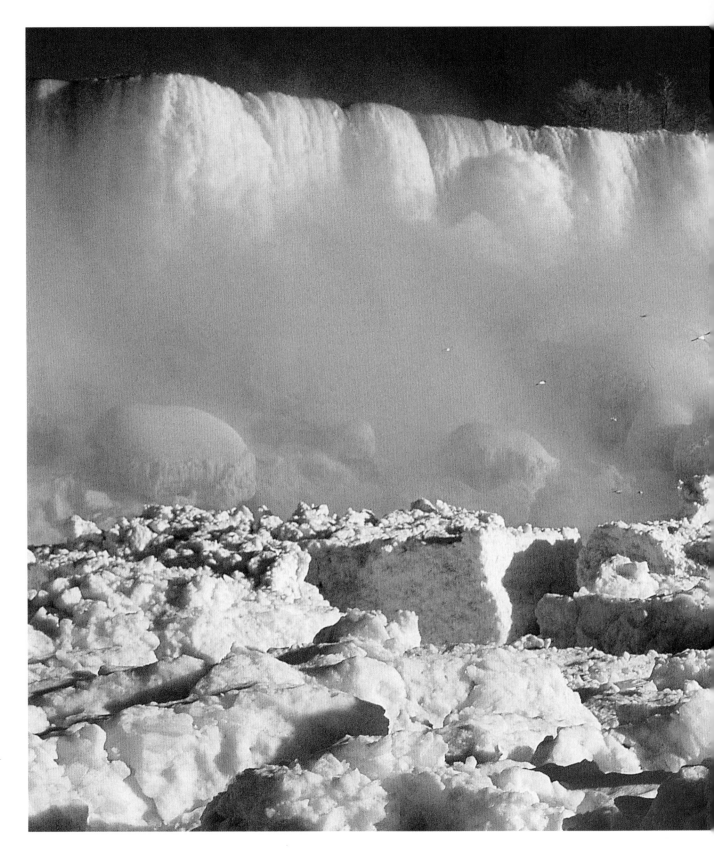

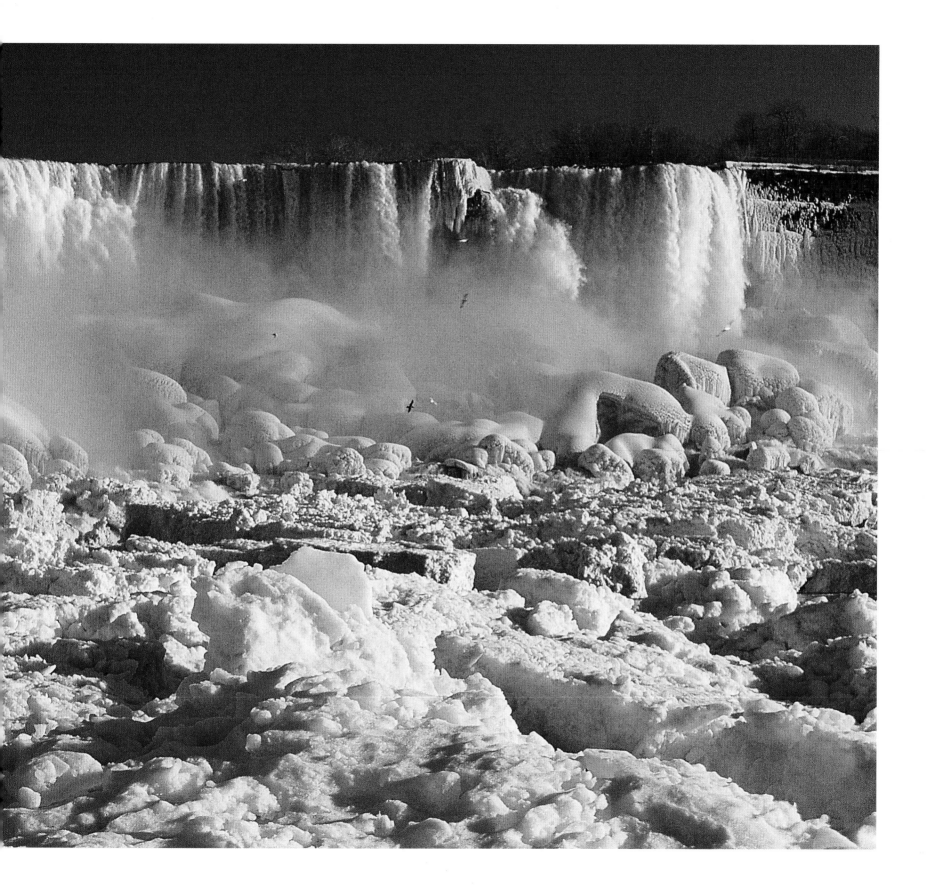

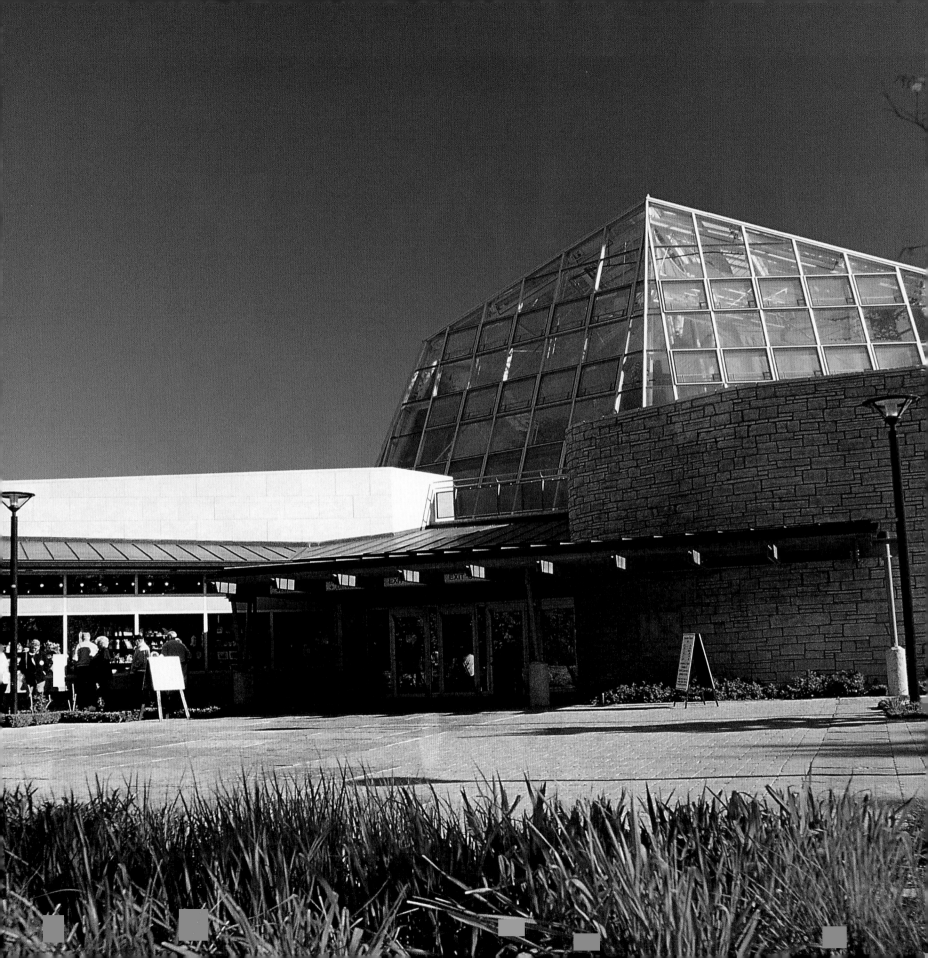

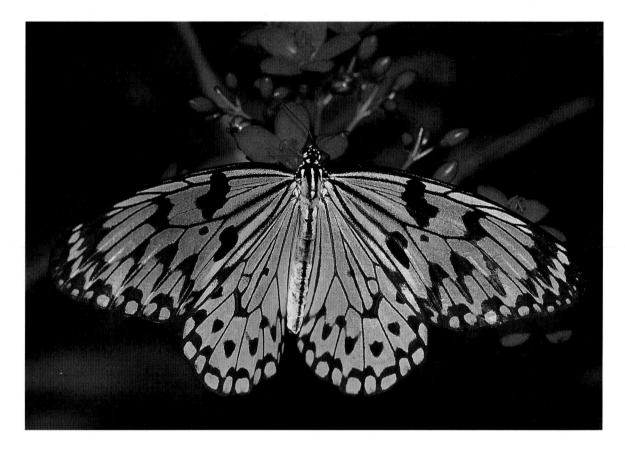

This vividly coloured butterfly is just one of about 2,000 in the Butterfly Conservatory. There are 45 species represented here, some in the process of emerging from their delicate cocoons.

In the Butterfly Conservatory, butterflies from Costa Rica, El Salvador, Florida, the Philippines, and around the world fly among vibrant blooms. Outside, a garden of nectar-rich flowers draws butterflies native to the local area.

Just downriver from the falls, the Spanish Aero Car has been providing spectacular views of the rapids and the gorge since 1916. Suspended on six cables, the car was designed by Spanish engineer Leonardo Torres Quevedo.

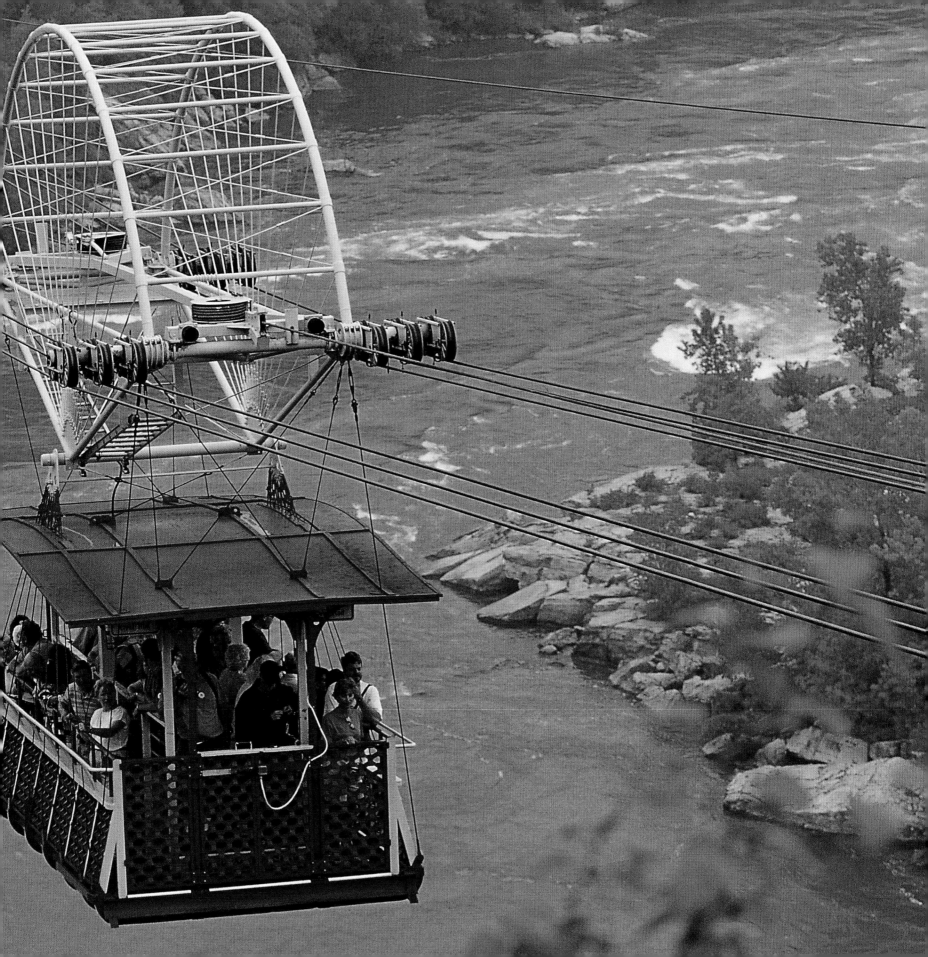

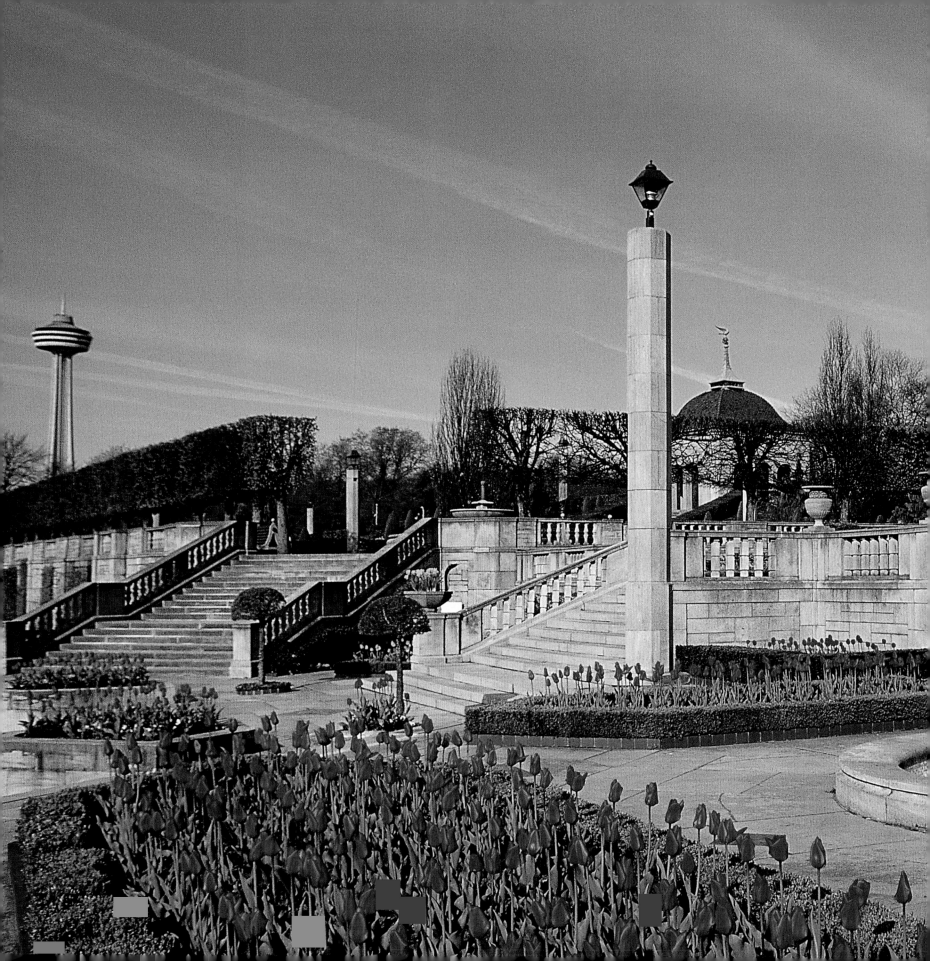

The Niagara Parks Commission, founded in 1885, maintains 1,619 hectares (4,000 acres) of green space. Sites range from formal flower beds to a unique fragrance garden, community walking paths, and golf courses.

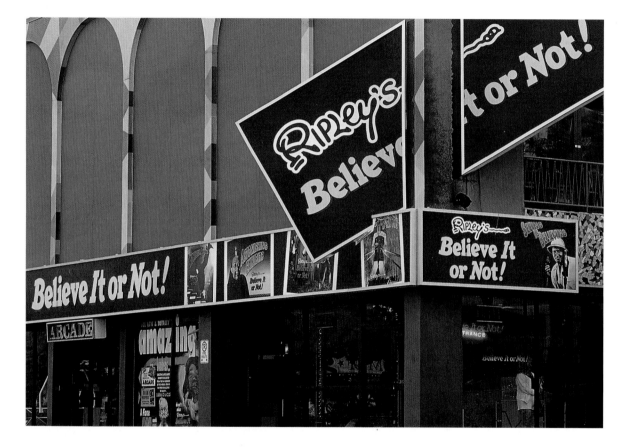

Shrunken human heads, shocking animal stories, and art created entirely from white bread—Ripley's Believe It or Not! museums amaze visitors in more than 25 locations around the world, including Niagara Falls.

Not surprisingly, tourism is the leading industry in the city of Niagara Falls, where 14 million visitors stay each year.

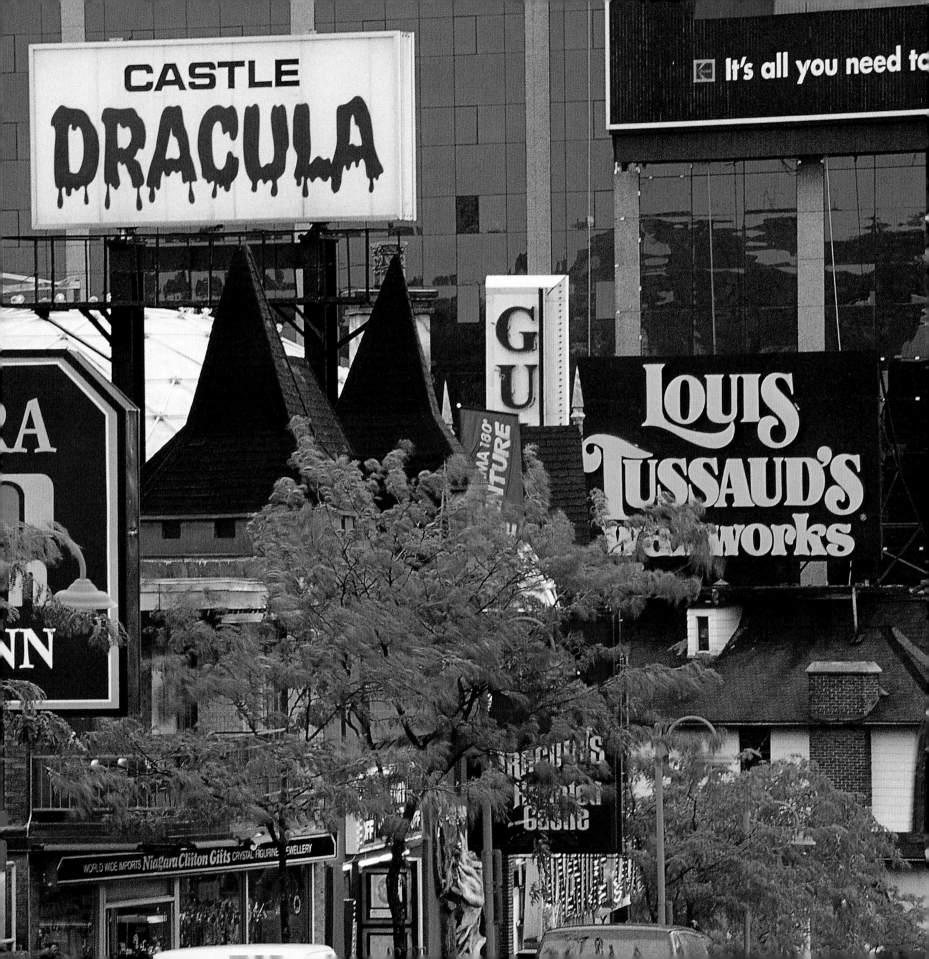

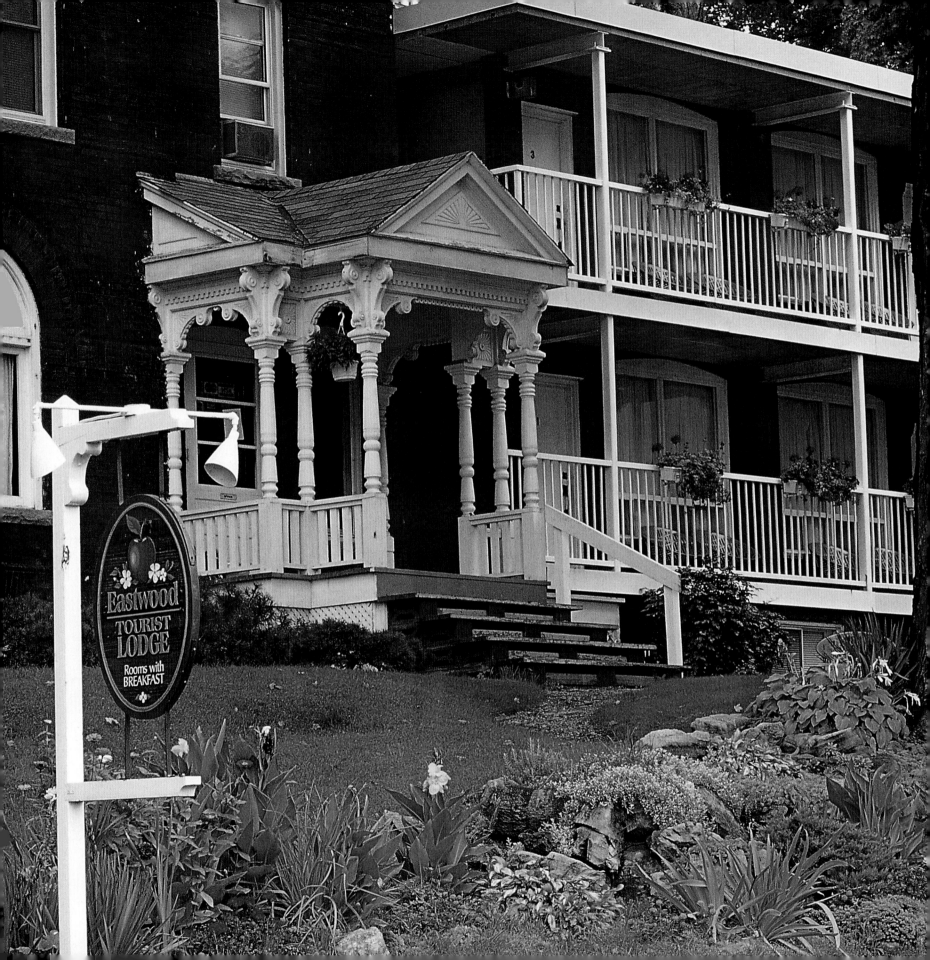

In the late 1800s, commercial development around the falls drew the attention of Lord Dufferin, Canada's governor general. He suggested that the area be declared a public park. The idea found wide support, and the organization that became the Niagara Parks Commission was born.

From historic homes to lavish guest lodges, hundreds of bed and breakfasts offer unique accommodation. Some are minutes away from the attractions of town, while others nestle among the vineyards and orchards of the peninsula.

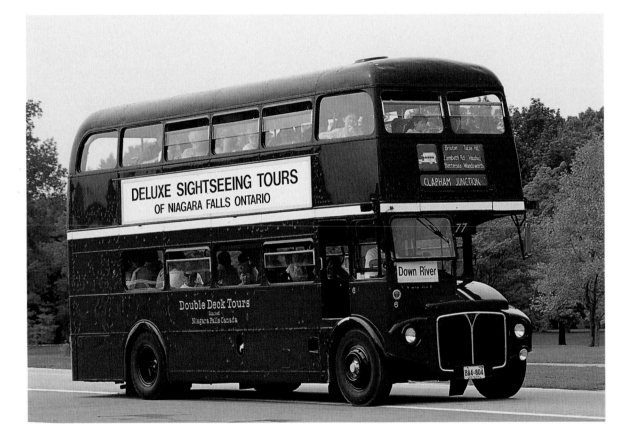

Visitors who have chosen to leave their cars at home can experience Niagara Falls aboard a double-decker tour bus. A local guide offers facts and anecdotes about each of the region's sites.

Up to 17,000 plants, including violas, *Alternathera, Santolina,* and California golden privet combine to form the Floral Clock, 26 metres (85 feet) in diameter. Designed in 1950, the clock is the largest of its kind in the world.

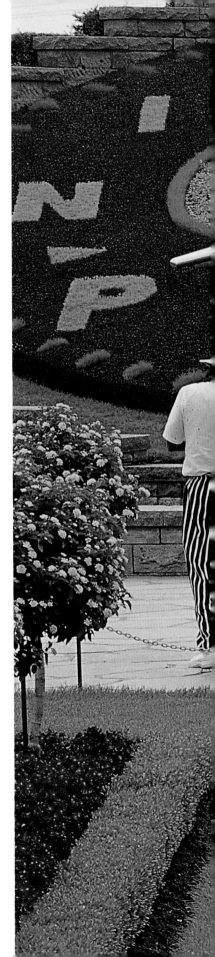

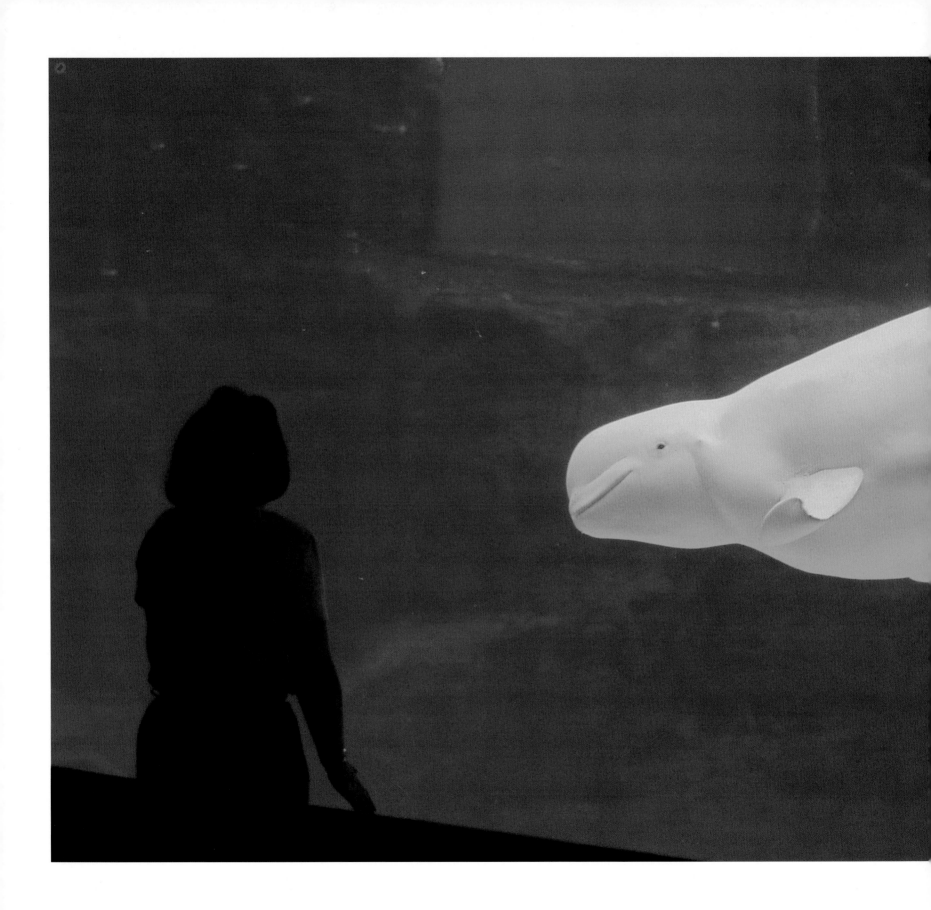

Friendship Cove at Marineland, billed as the world's largest artificial orca habitat, is also home to three beluga whales. Underwater viewing rooms and outside walkways allow visitors a close look at these enormous animals.

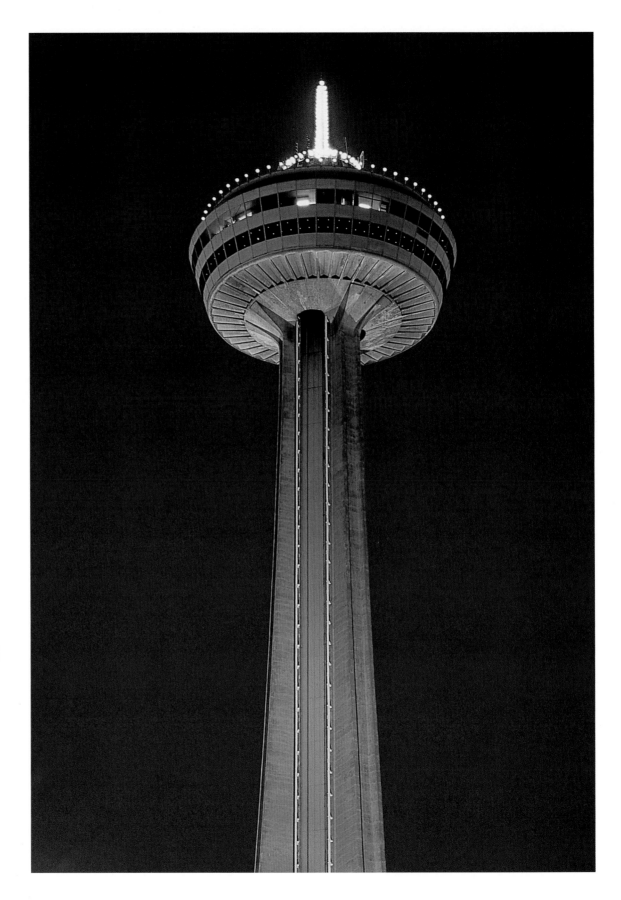

Rising more than
153 metres (500 feet)
from the precipice, Skylon
Tower offers a breathtaking
view down to the pool at
the base of Niagara Falls.
About 4590 cubic metres
(6,000 cubic yards) of
concrete were used in the
construction of the tower,
poured around-the-clock
for more than a month.

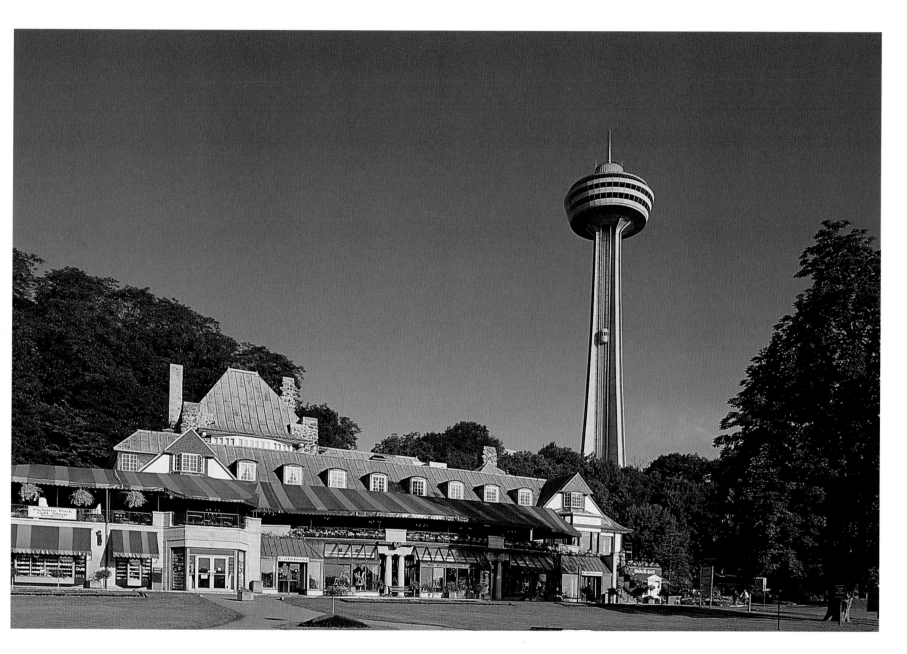

Visitors can choose to dine surrounded by gardens at the Victoria Park Restaurant, or 236 metres (775 feet) above the base of the falls in Skylon Tower's revolving dining room.

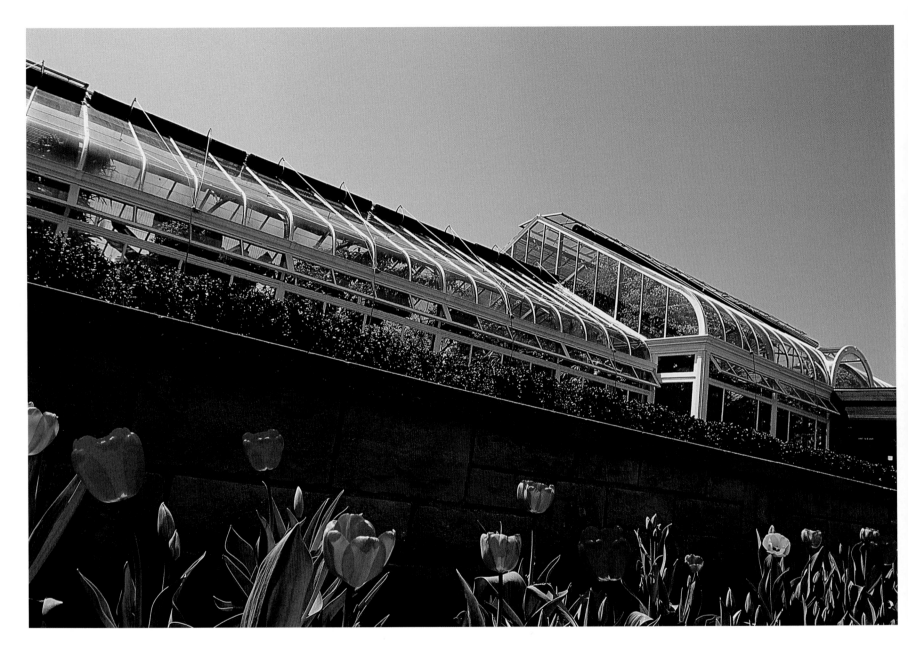

The constantly changing blooms of the Niagara Parks Greenhouse—
from the Easter Display of lilies and spring bulbs to the Christmas Show
of poinsettias, cyclamens, and cacti—draw thousands of flower enthu-
siasts each year. The structure was built in 1945 and expanded in 1990.

Carefully tended gardens surround the Niagara Parks Greenhouse, including a display for visually impaired visitors. The creators selected plants for their fragrances and labelled many of the species in braille.

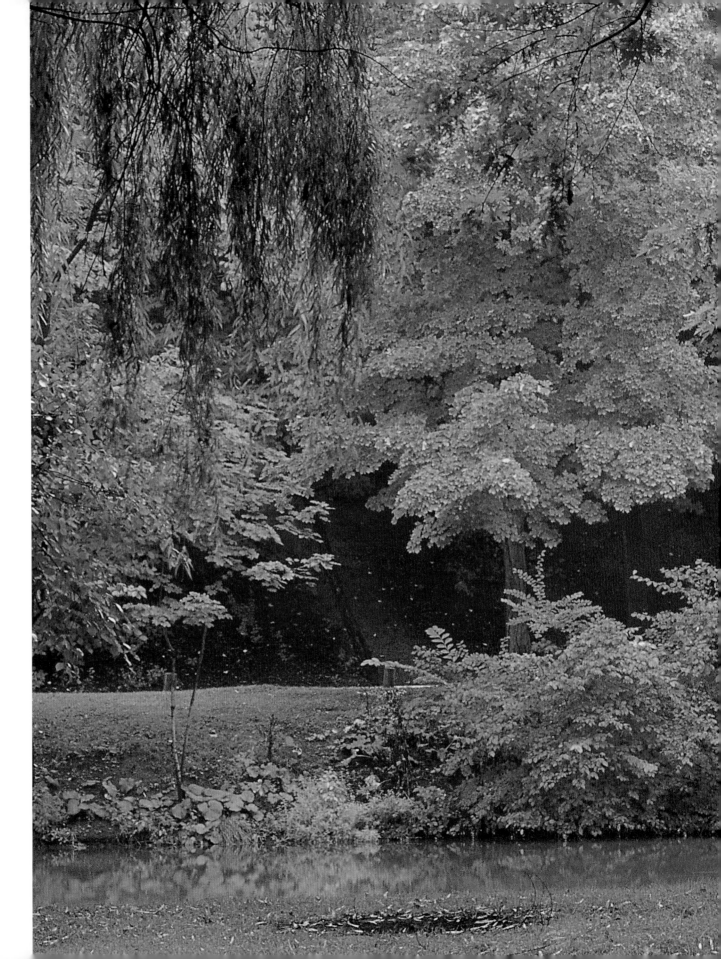

Just south of the falls, the Dufferin Islands allow visitors to escape into a serene setting of ponds and groves, gently sloping lawns, and picturesque picnic sites. The area is a favourite with bird watchers, and a catch-and-release program draws increasing numbers of anglers.

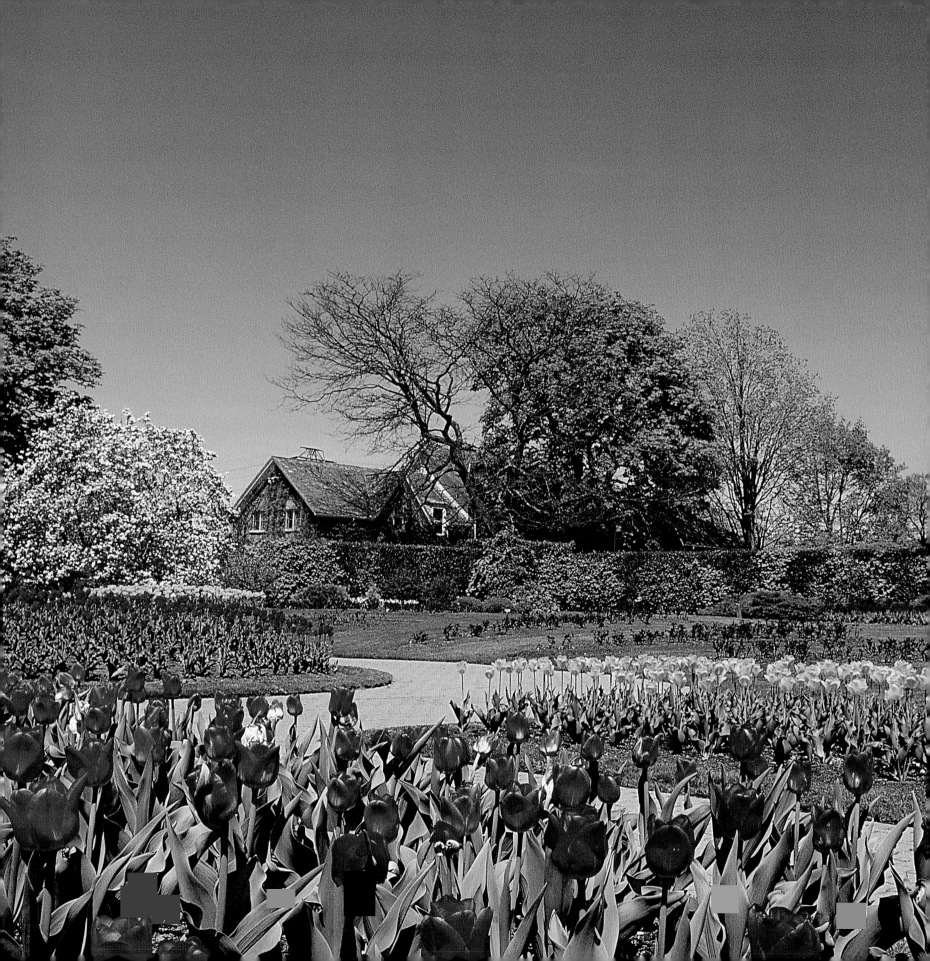

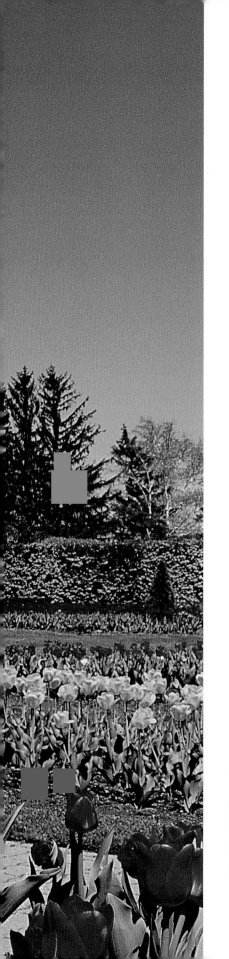

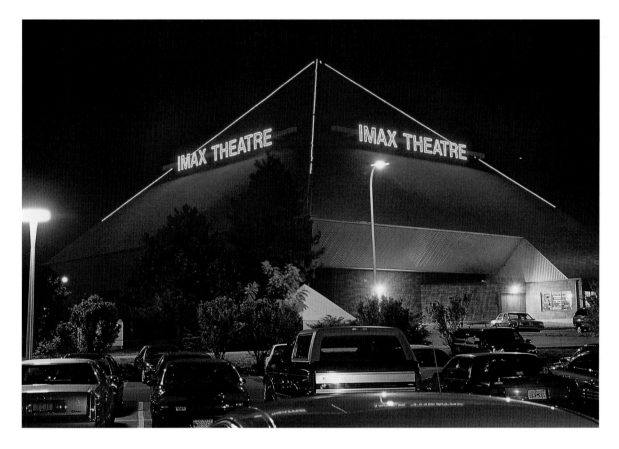

As well as showing films from around the world, the IMAX Theatre and Daredevil Adventure whisks visitors on a tour of the Niagara region, from the plunging waters to the vineyards just a few kilometres (miles) away.

Forty hectares (100 acres) of beautifully landscaped gardens attract about 750,000 visitors each year to the Niagara Parks Botanical Gardens and School of Horticulture. The school, one of the most respected in Canada, accepts only 12 to 14 new students each year.

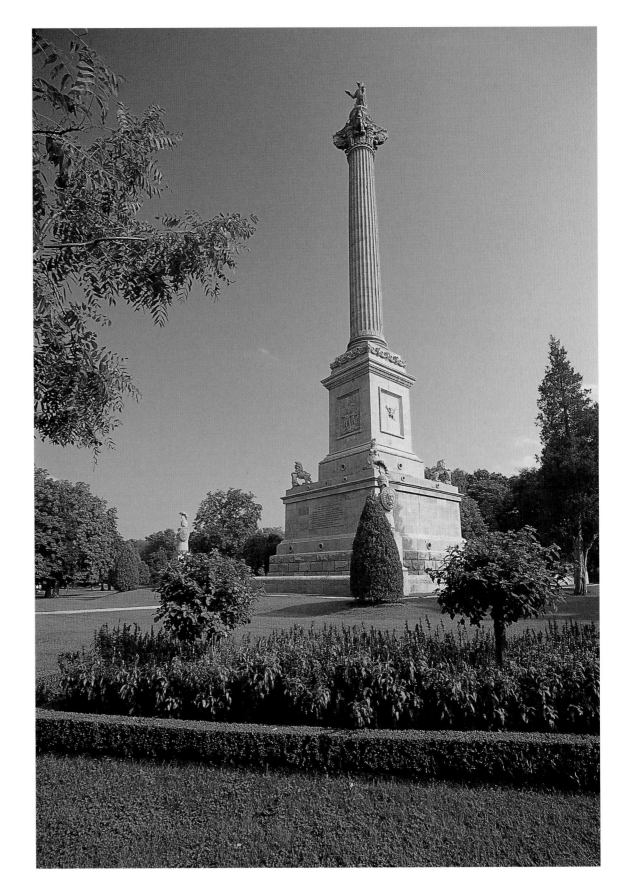

This monument commemorates the acts of General Isaac Brock, who fought and died in Queenston during the War of 1812. The first monument at this site, built in 1824, was destroyed by a bomb in 1838. The present monument was created 15 years later.

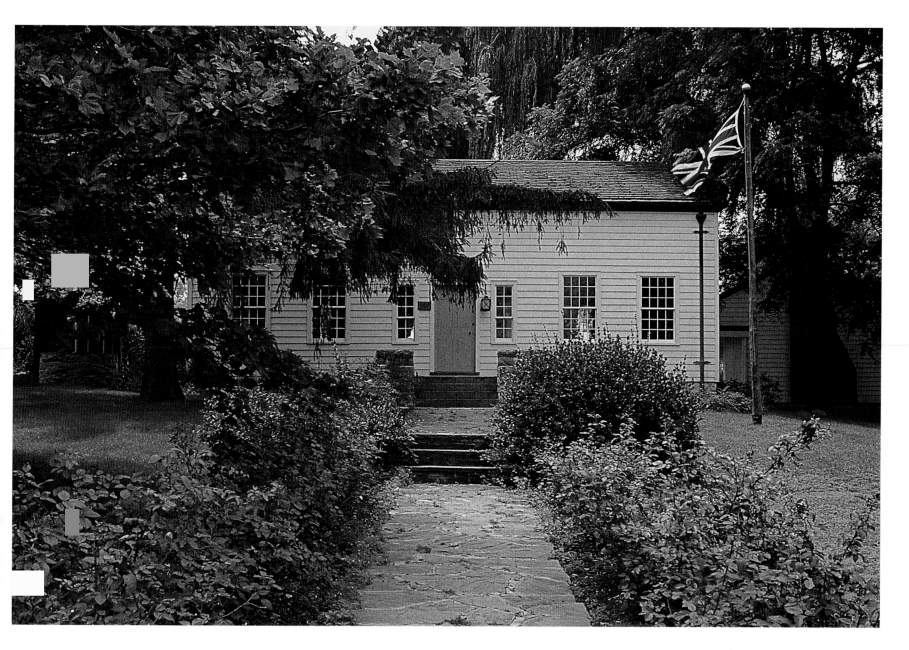

Faithfully preserved and featuring original 1812 furnishings, Laura
Secord's home stands as a monument to her heroism during the
War of 1812. After learning of an American attack, Secord journeyed
32 kilometres (20 miles) alone to warn the British forces.

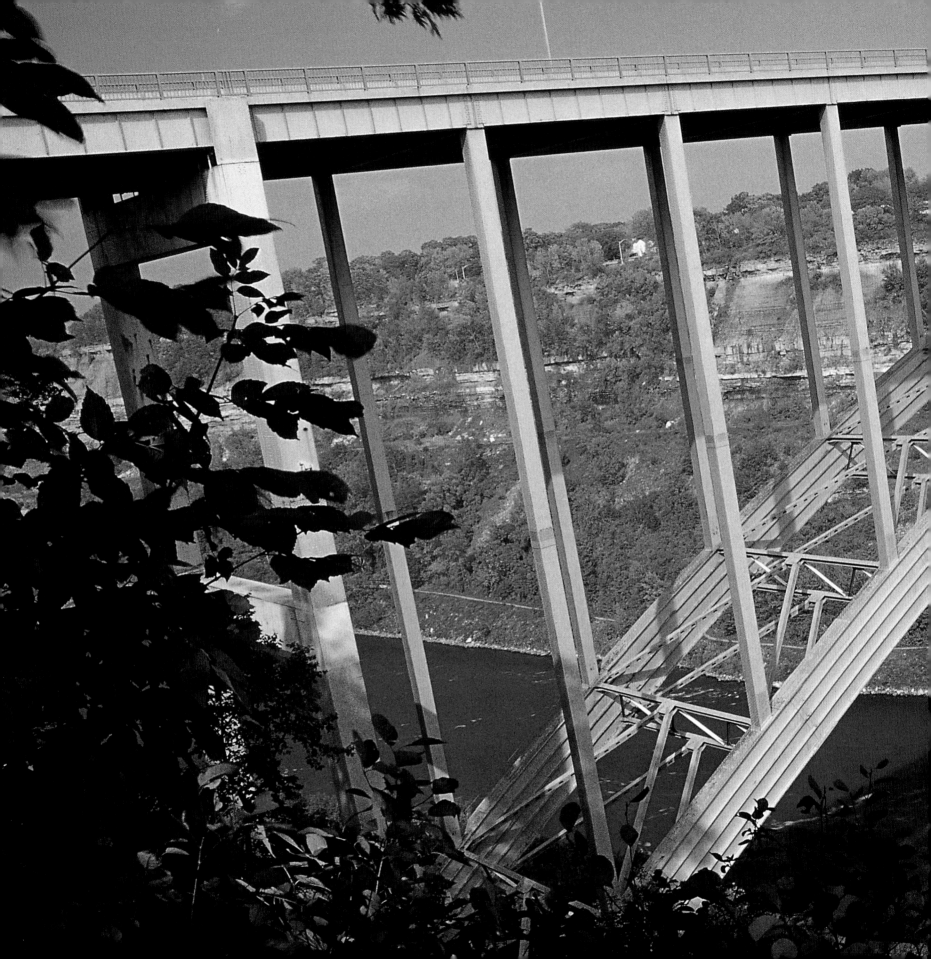

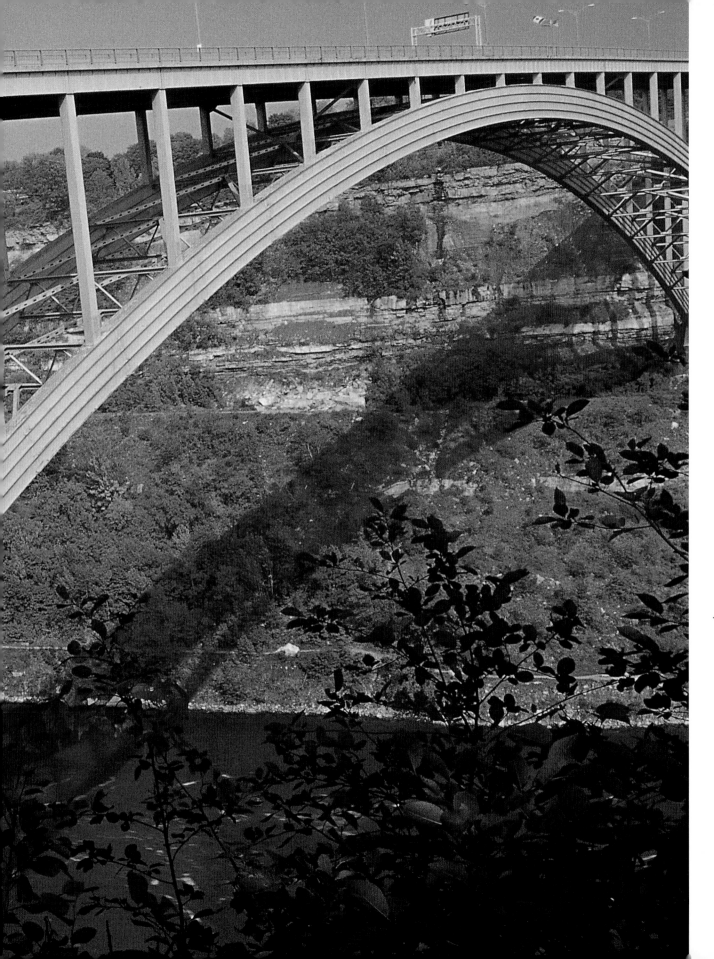

The Lewiston-Queenston Bridge joins Niagara-on-the-Lake, Ontario to Lewiston, New York. This is one of four spans linking the peninsula to the United States. One-quarter of all border crossings from the U.S. to Canada are made on these bridges.

41

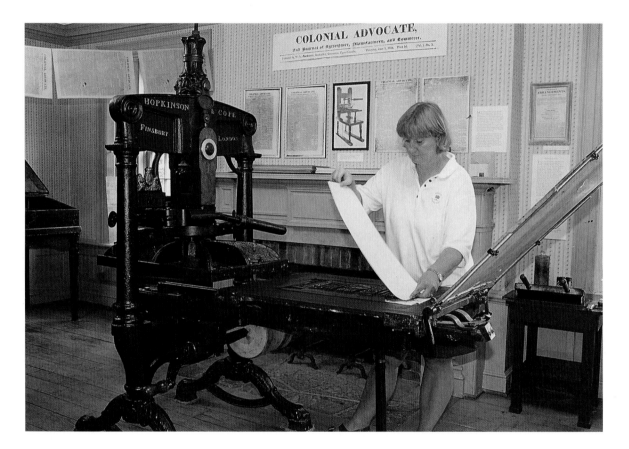

Featuring the oldest printing press in the country and one of the only wooden presses in the world, the Mackenzie Heritage Printery Museum commemorates centuries of printing technology.

At the Mackenzie Heritage Printery, visitors learn about William Lyon Mackenzie, editor of the *Colonial Advocate* and a fierce proponent of responsible government. The museum was opened in 1938 by the printer's grandson, Prime Minister William Lyon Mackenzie King.

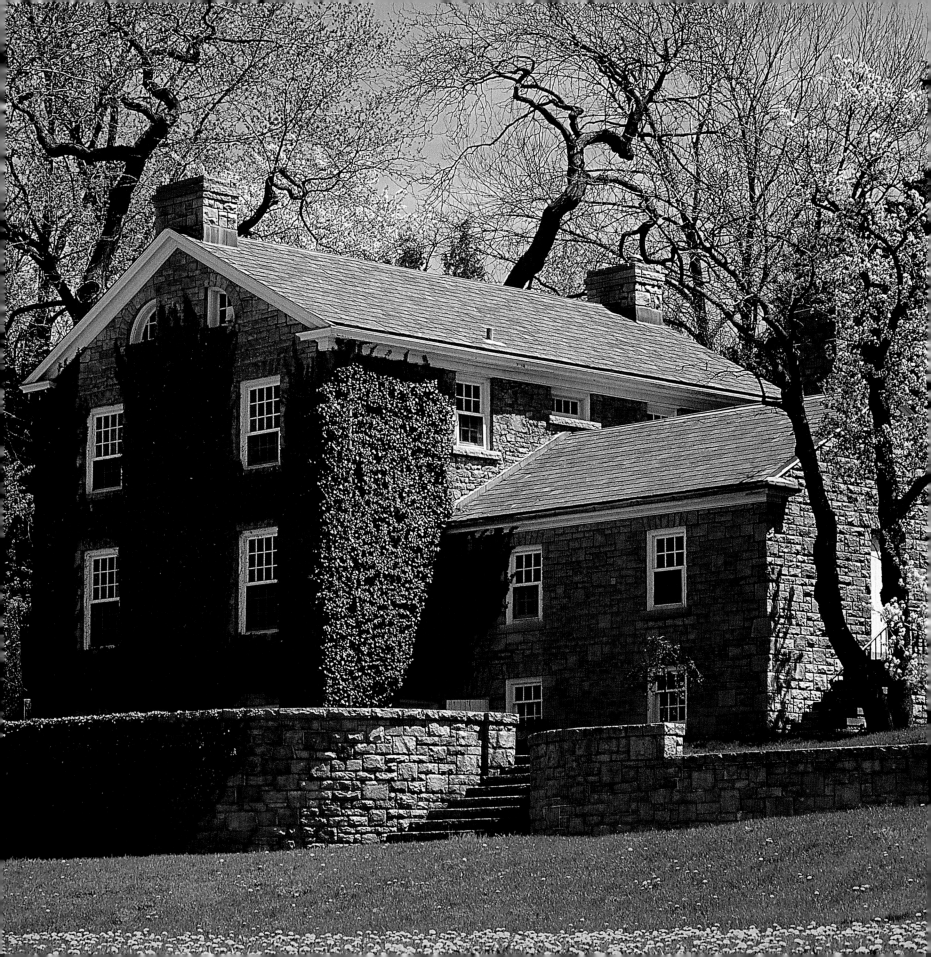

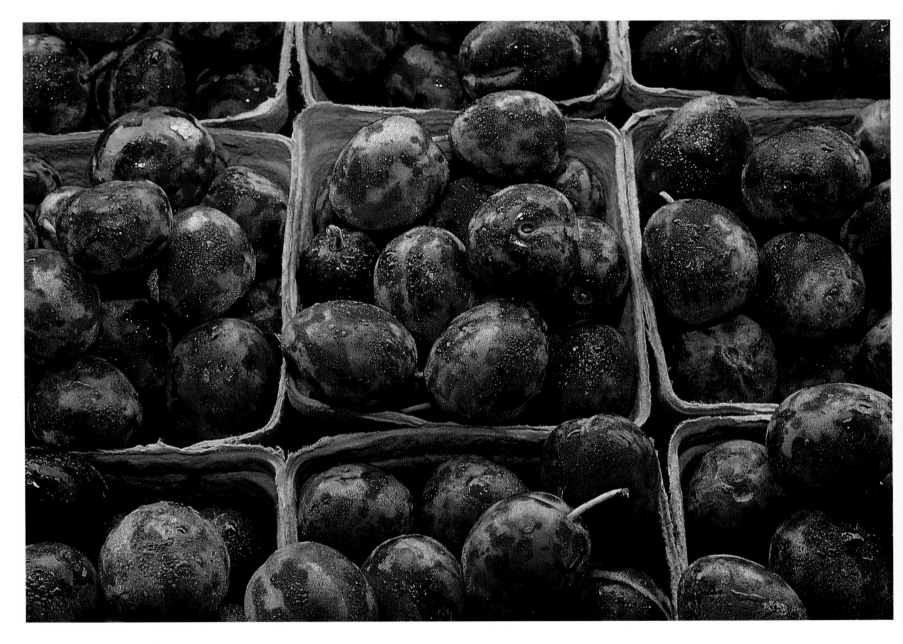

Long before the arrival of Europeans, Ontario's First Nations were growing crops including corn, squash, and beans. Today, farmers in the Niagara region take advantage of the area's mild microclimate to grow tree-fruits and grapes.

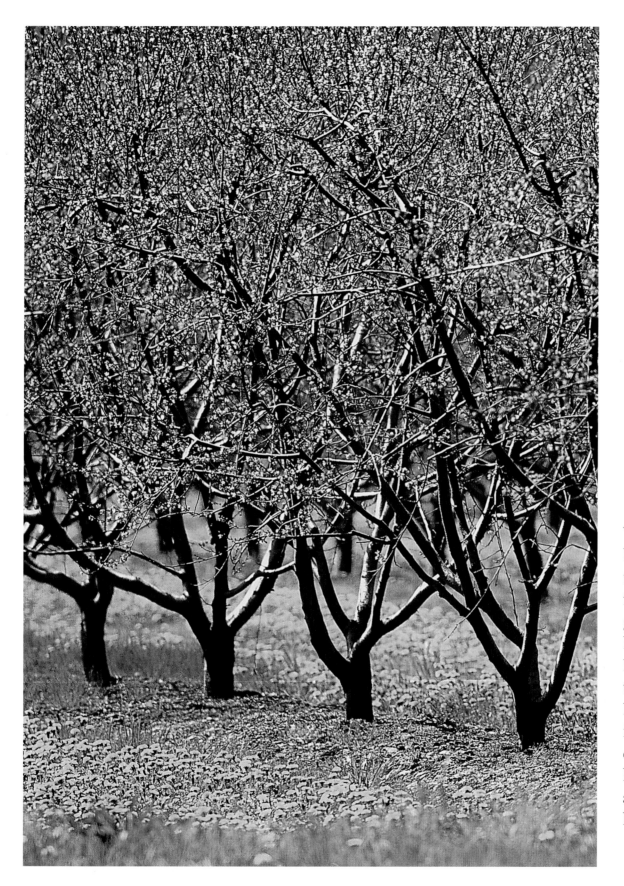

When the Loyalists began to arrive in the Niagara region in 1781, the British government bought land along the Niagara River from the local First Nations in exchange for 300 suits of clothing. One year later, 16 families had already cleared 95 hectares (236 acres).

There are a dozen wineries within a 15-minute drive of Niagara Falls. Most sell their wines under the Vintners Quality Alliance medallion. Among other things, this seal certifies that the wines are made only with Ontario-grown grapes.

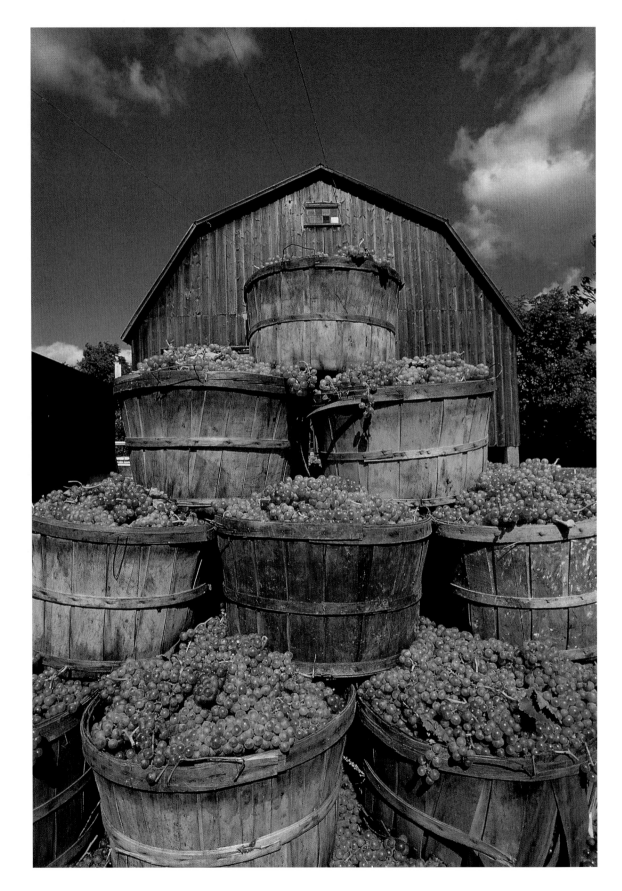

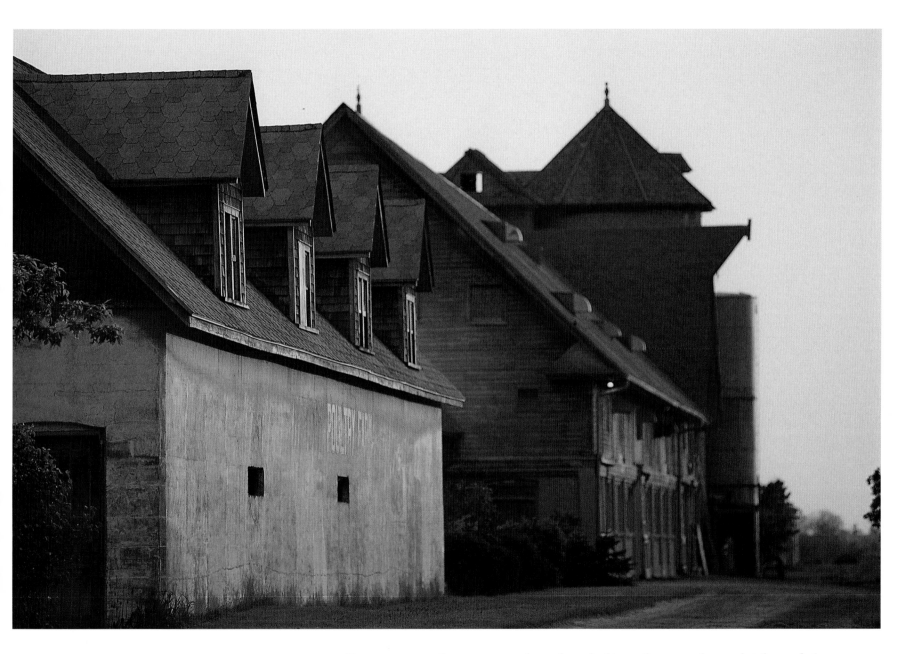

Barns, greenhouses, and orchards line the rural roadsides of the region. The leading products of the Niagara Peninsula's many farms are apples, peaches, plums, pears, grapes, strawberries, and cherries.

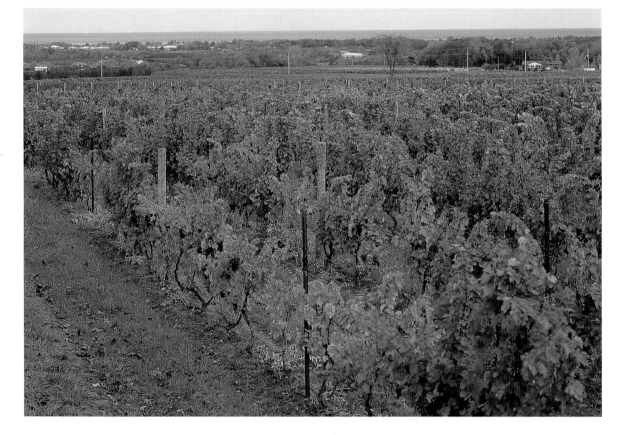

Thousands of years ago, receding glaciers deposited clay, loam, sand, and gravel over the Niagara Peninsula. Today, this glacial mix combines with minerals from the bedrock to provide perfect soil for local vineyards.

Ontario's wines have won competitions and acclaim in England, Italy, and the United States. Some of the most successful have been ice wines, Chardonnay, Riesling and Pinot Blanc white wines and Cabernet Sauvignon, Cabernet Franc, Merlot, and Pinot Noir reds.

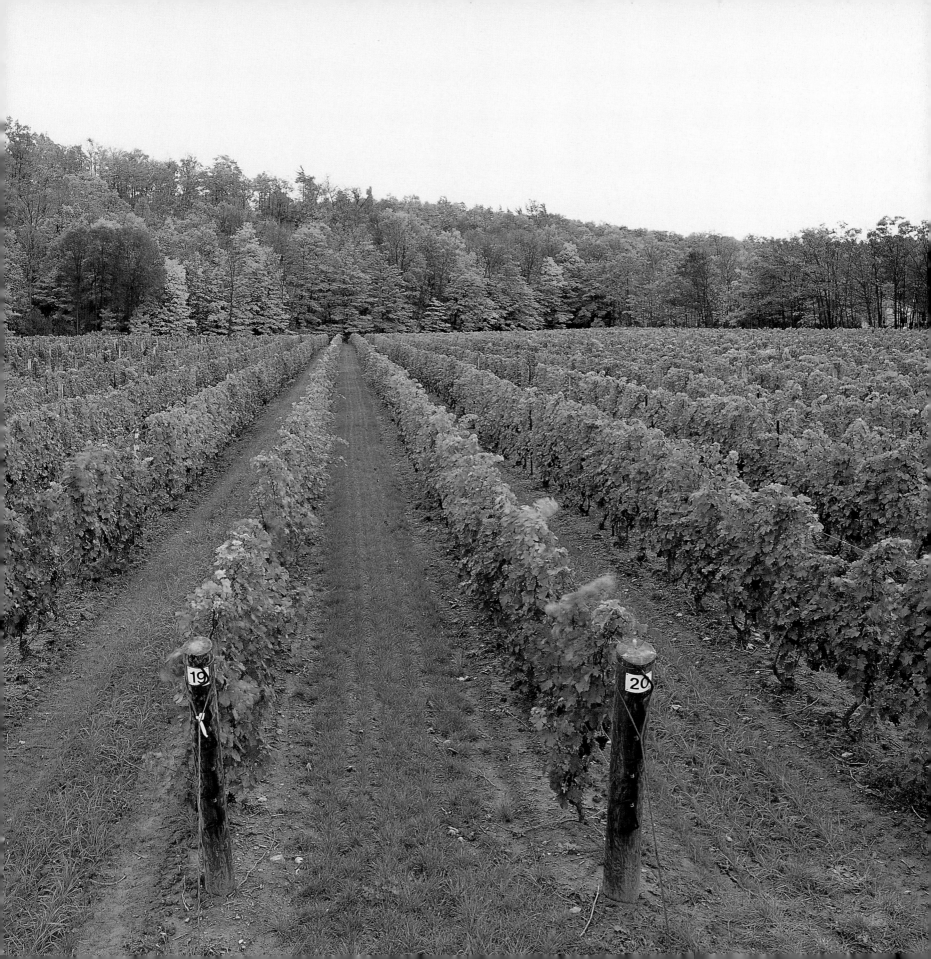

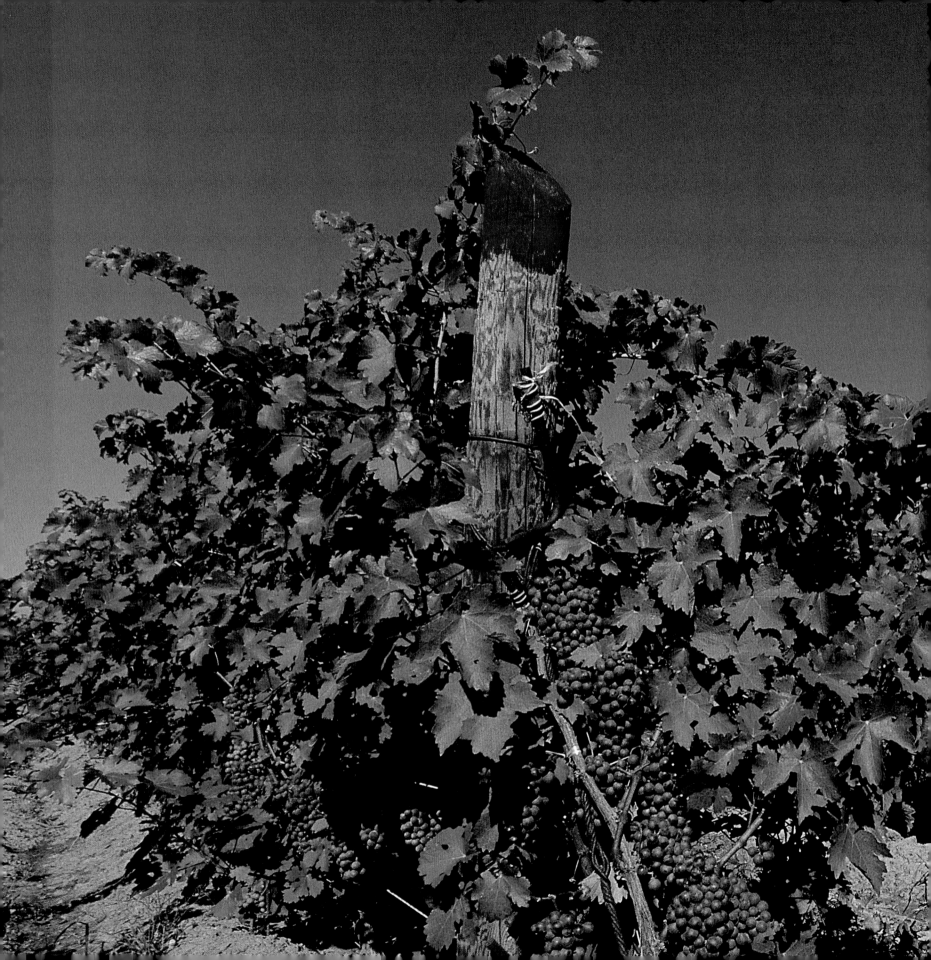

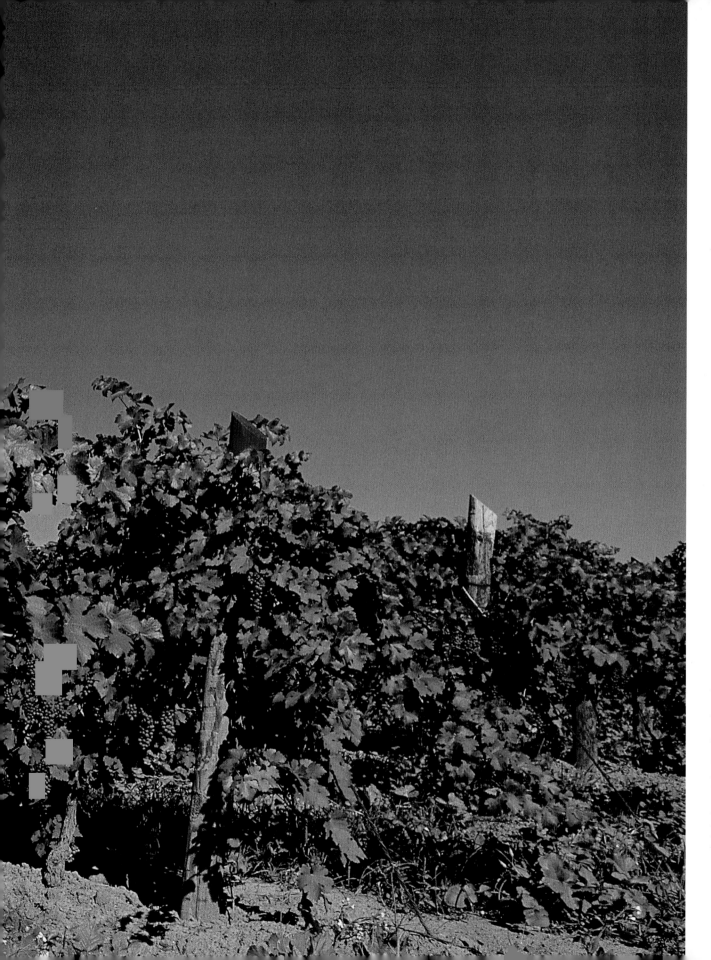

There are 6,070 hectares (15,000 acres) of vineyards in Ontario, most in the Niagara region. They grow more than 80 percent of Canada's wine grapes.

51

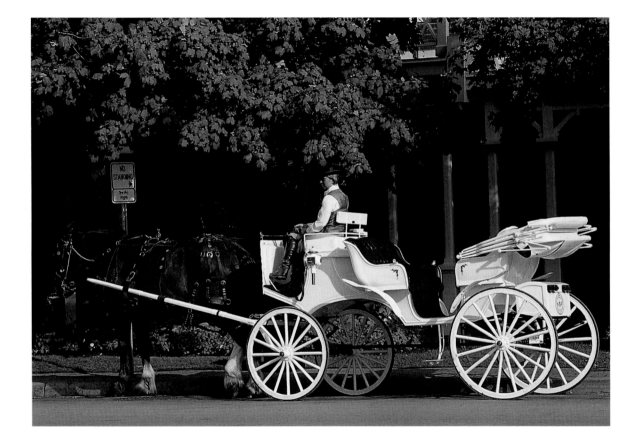

A horse-drawn carriage ride past historic 19th-century buildings is one way to see Niagara-on-the-Lake as it was a century ago. The town's picturesque main street is lined with shops, galleries, and cafés.

From 1792 to 1796, Niagara-on-the-Lake, then known as Newark, served as the first seat of government for Upper Canada. Destroyed during the War of 1812, the town was rebuilt as a thriving commercial centre a few years later.

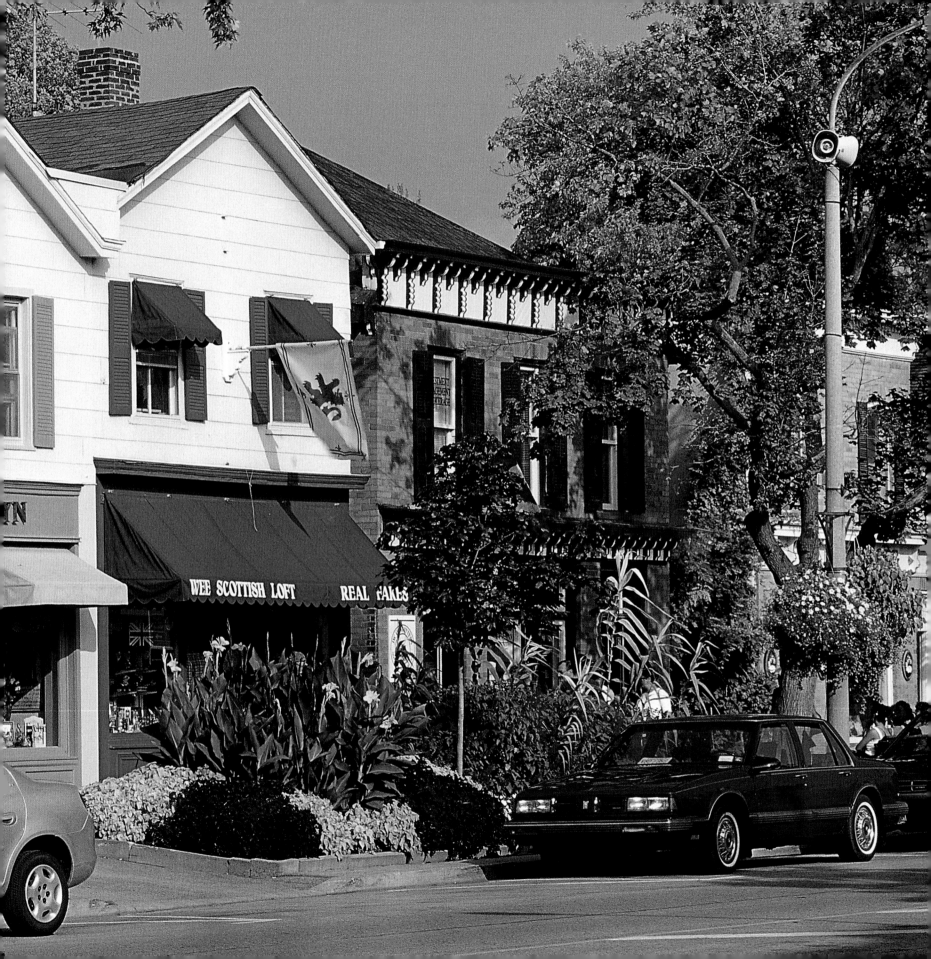

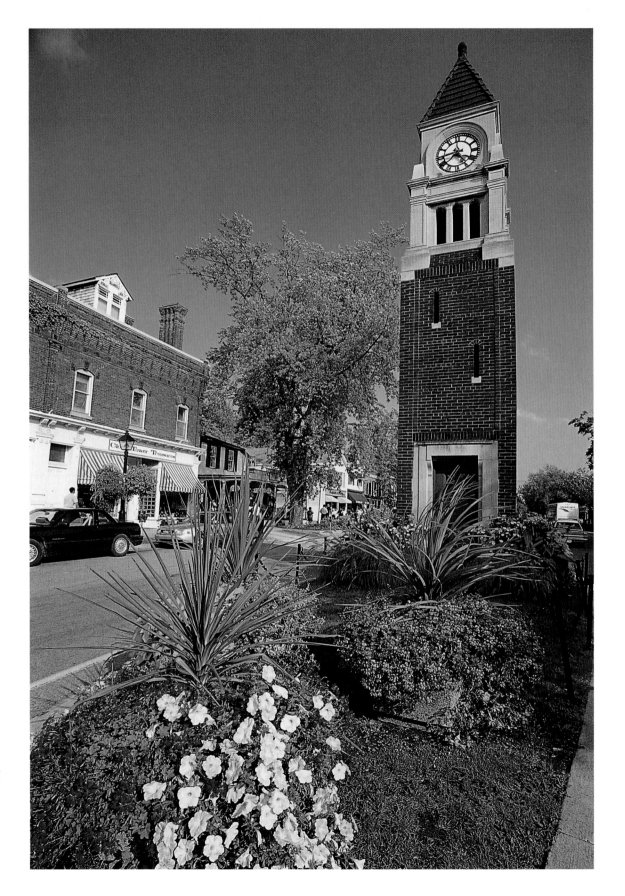

Built in 1922, the Clock Tower on Queen Street in Niagara-on-the-Lake was designed as a tribute to the 10 local men killed in World War I. The names of those lost in World War II were later added.

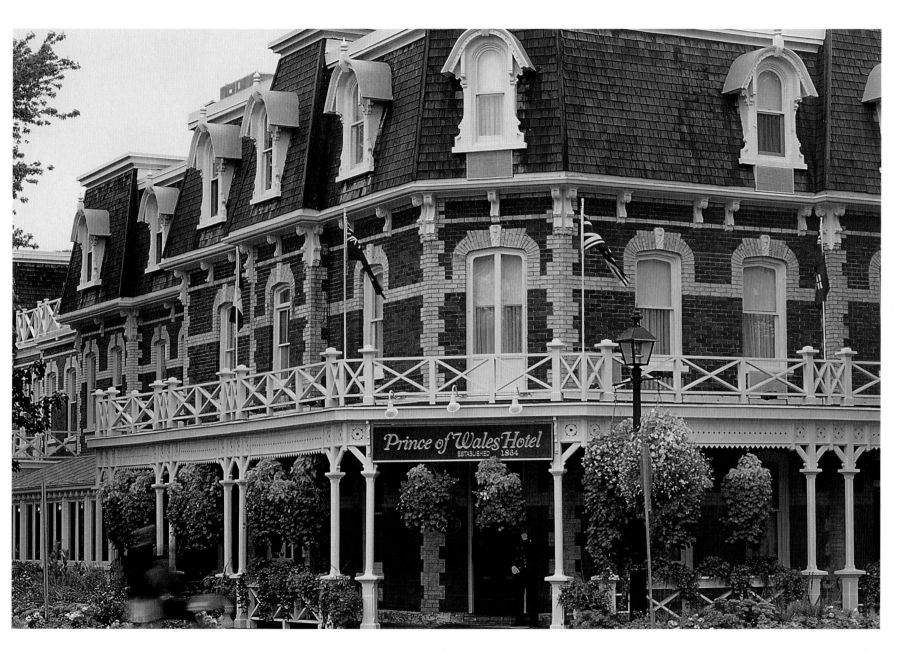

Niagara-on-the-Lake's historic Queen Street is home to the Prince of Wales Hotel, the stately Court House, and the Niagara Apothecary, which operated as a pharmacy from 1819 to 1971. When it finally closed, the restored building was converted into a museum.

The Shaw Festival is the only theatre group in the world specializing in the works of George Bernard Shaw and his contemporaries. The group presents Victorian dramas, rare plays, classical musicals, and more.

The Court House in Niagara-on-the-Lake was the Shaw Festival's first venue. Rarer and more challenging plays are still presented here, where audiences enjoy an intimate 316-seat setting.

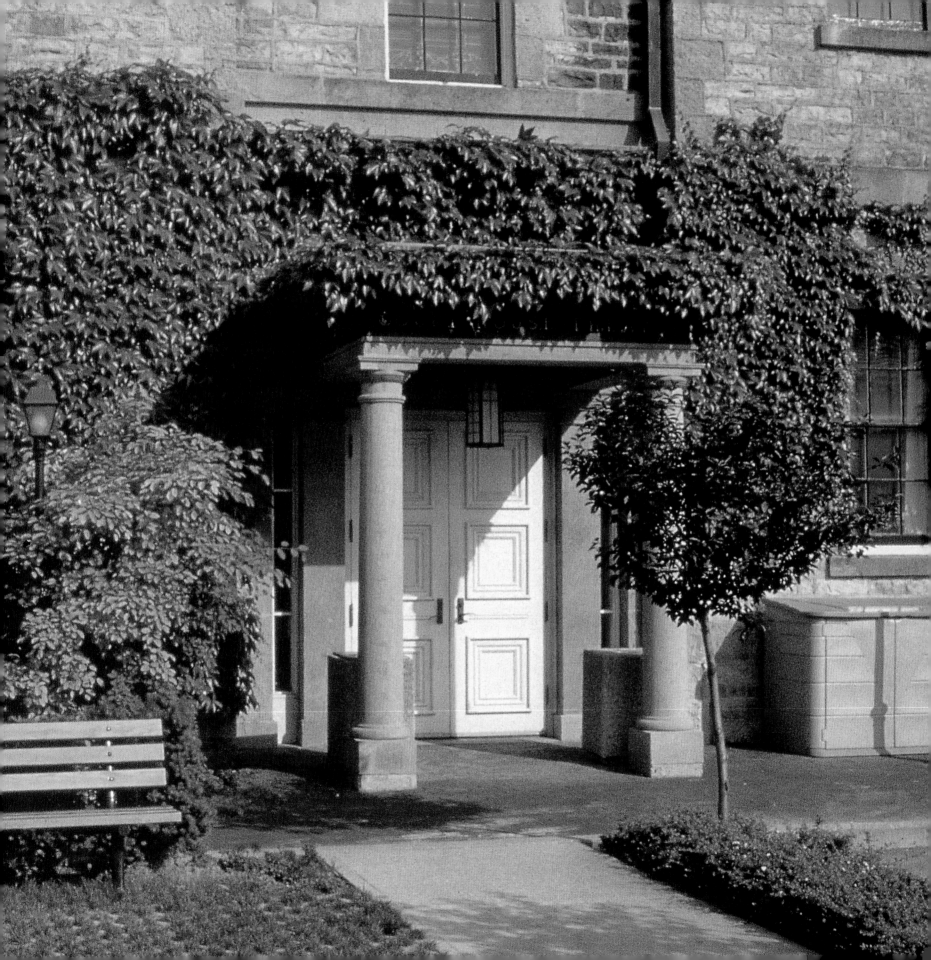

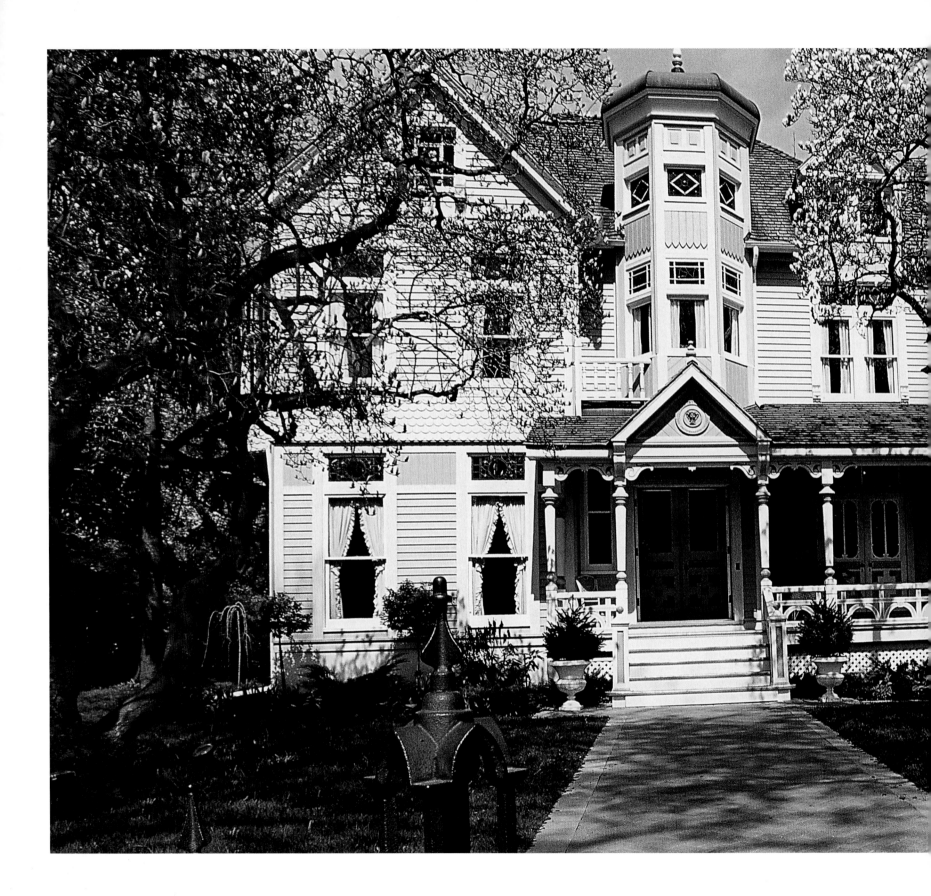

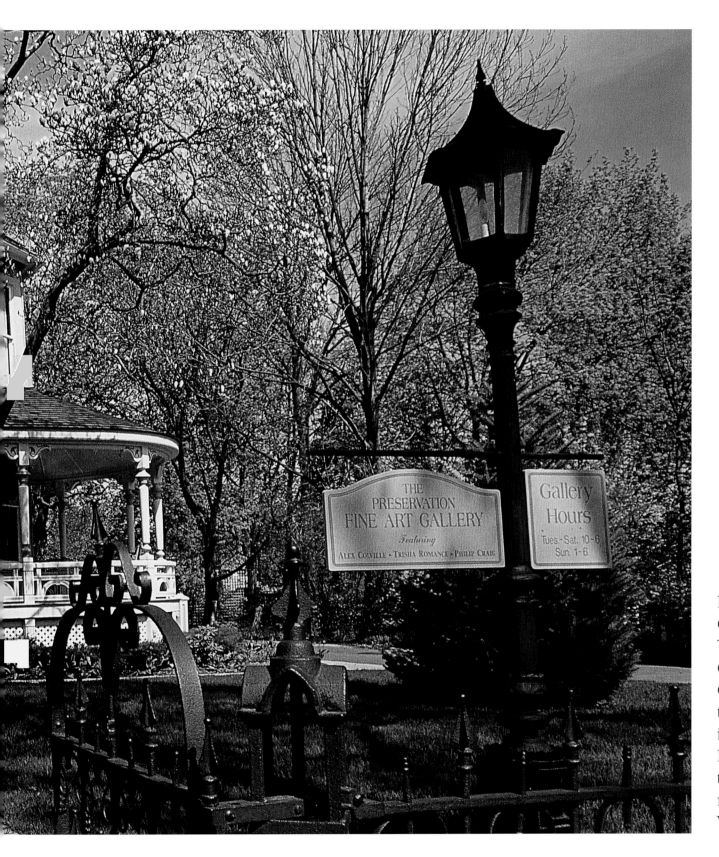

Home to works by Canadian artists Trisha Romance, Alex Colville, and Philip Craig, the Preservation Fine Art Gallery in Niagara-on-the-Lake displays art in the antique-furnished rooms of a stately Victorian house.

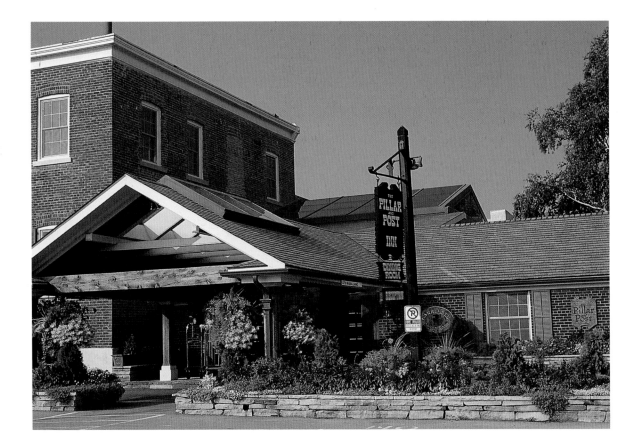

At the Pillar and Post Inn in Niagara-on-the-Lake, guests enjoy bouquets
of fresh flowers brightening the rooms, a lavish spa to ease any worries,
fireplaces, whirlpool baths, and world-class cuisine.

Old Fort Niagara in Youngstown, New York, remains from
the time when British and French forces fought for control
of the continent. In 1759, the fort withstood a siege by
3,500 British and Iroquois fighters for more than two
weeks before the French forces surrendered.

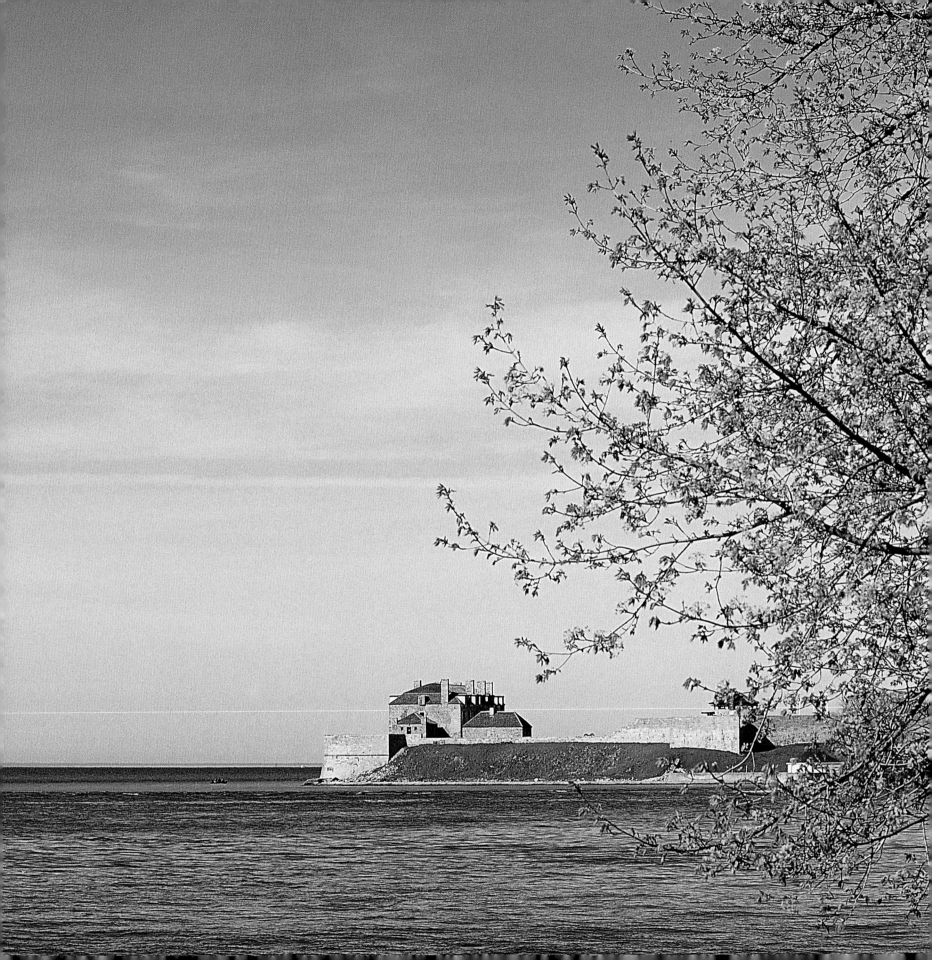

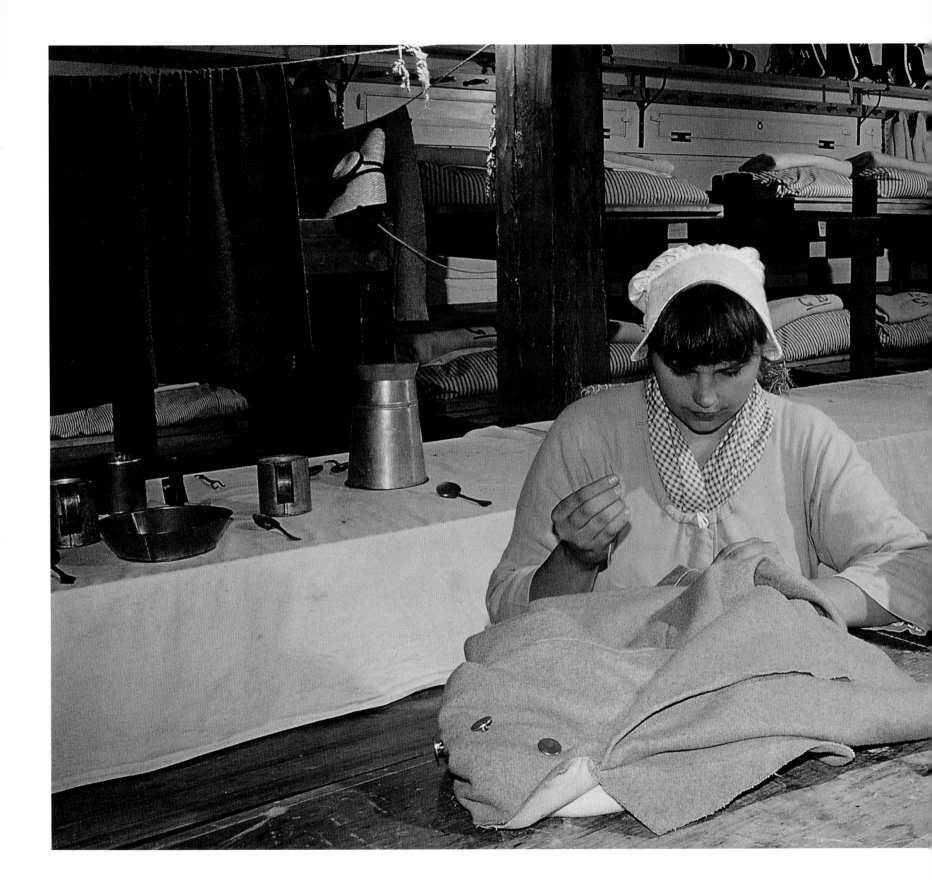

Inside Fort George, costumed staff bring the days of the early 19th century to life. While soldiers perform their drills and regiments prepare for battle, it's easy to imagine that the War of 1812 continues to rage just outside the stone walls.

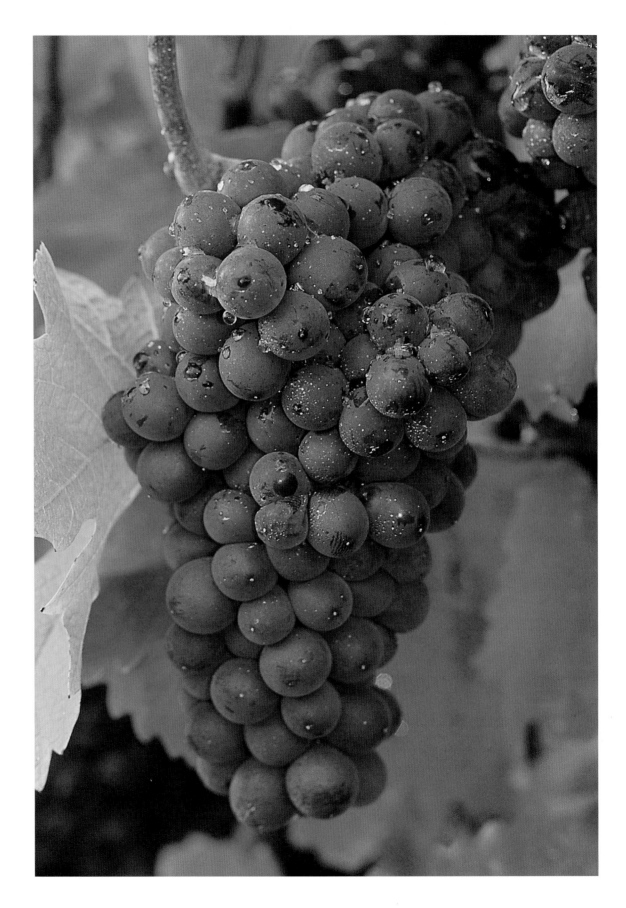

The Niagara Peninsula lies from 41 to 44 degrees north latitude, about the same latitude as Provence in France. The Great Lakes help to control the temperature, while the Niagara Escarpment blocks strong winds.

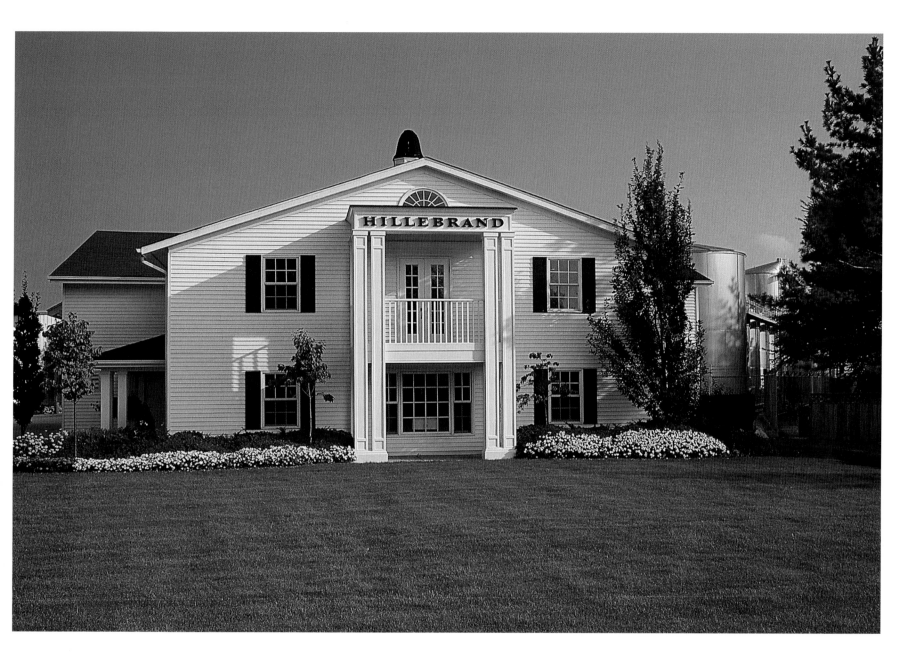

Since its founding in 1982, Hillebrand Estates Winery has gained fame for its red and white vintages along with its unique icewine. Made from grapes that have frozen on the vine and been harvested in December and January, Hillebrand's icewine is known around the world.

St. Catharines' stately courthouse, 200-year-old churches, and dozens of heritage buildings remind sightseers of the city's past. Five walking tours, including the Old Town, Port Dalhousie, and the Mountain Locks, offer fascinating glimpses of historic sites.

St. Catharines was first settled by Loyalists John Hainer and Jacob Dittrick in about 1790. It grew steadily as a farming and commercial centre and retains its agricultural roots, although, with a population of more than 130,000, the city is now the largest in the region.

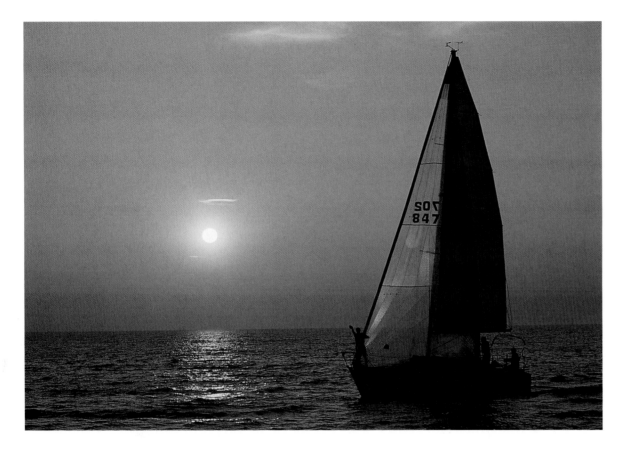

In the early 1820s, escaped slaves began arriving in the St. Catharines area, fleeing the United States across Lake Ontario. Many were helped to freedom by Harriet Tubman, a local supporter of the Underground Railroad.

Built in 1852 and automated just over a century later, the Port Dalhousie Front Range Light stands 460 metres (1,500 feet) from shore, guiding vessels to the harbour entrance.

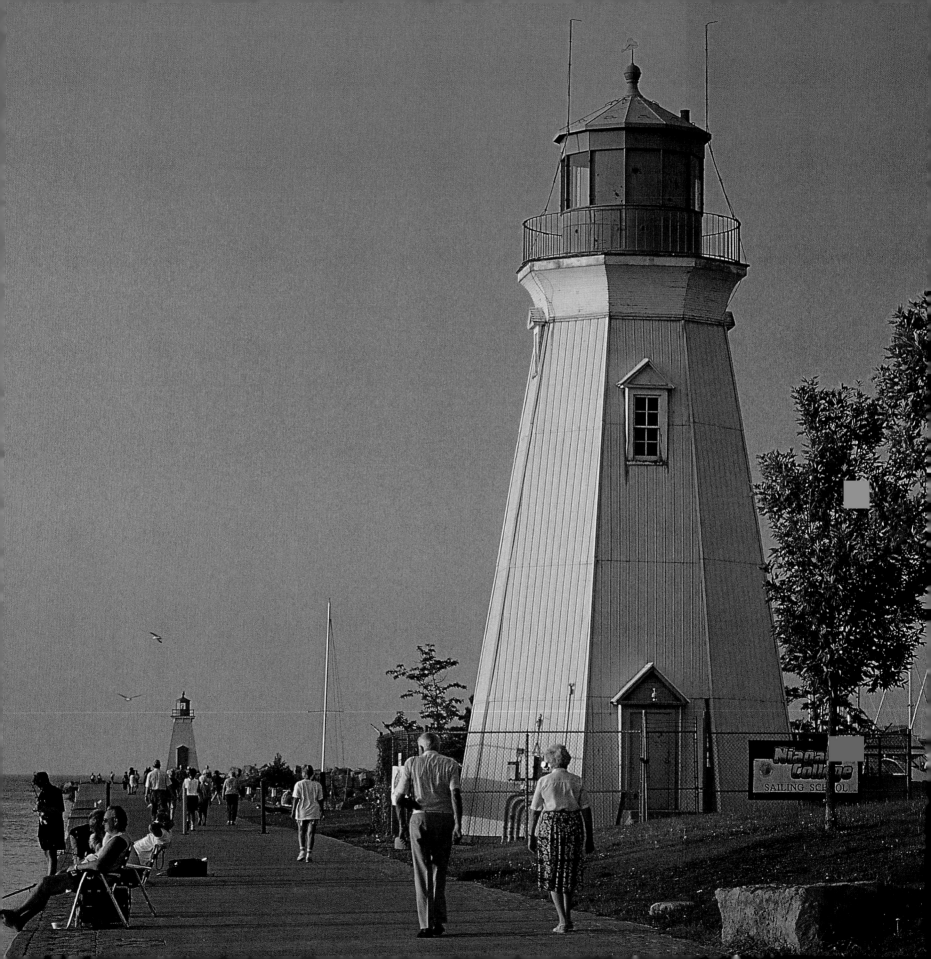

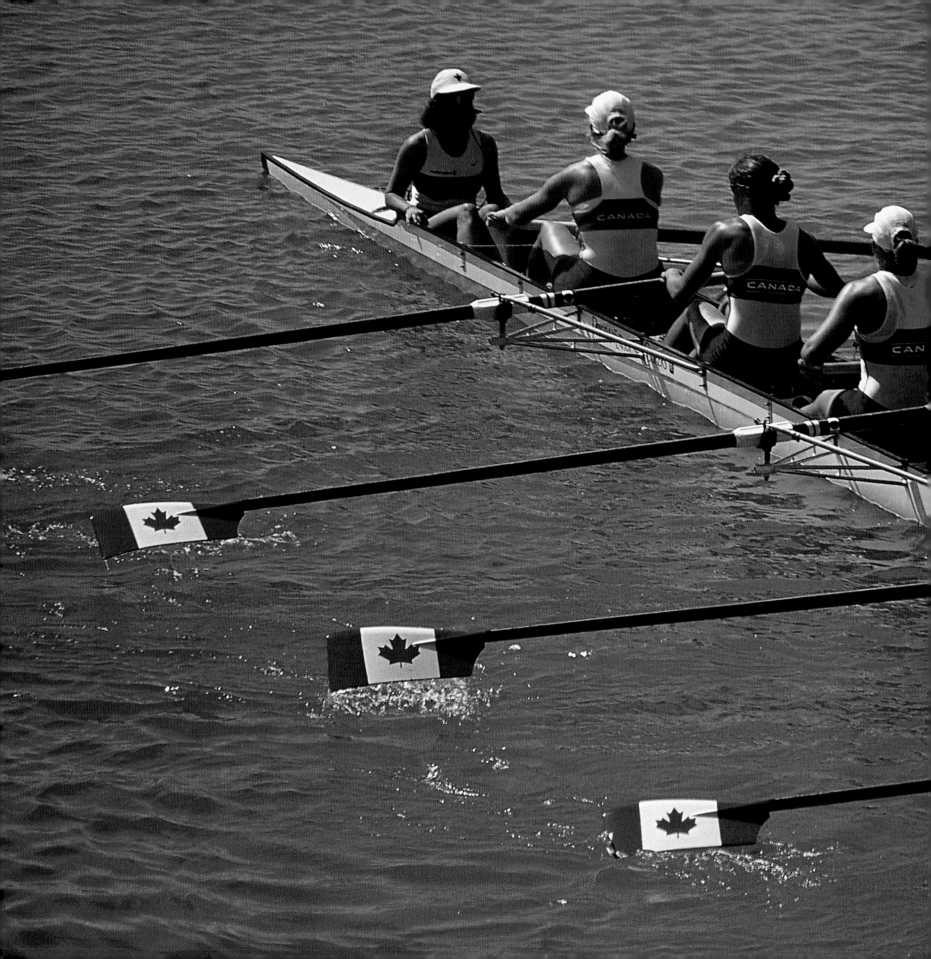

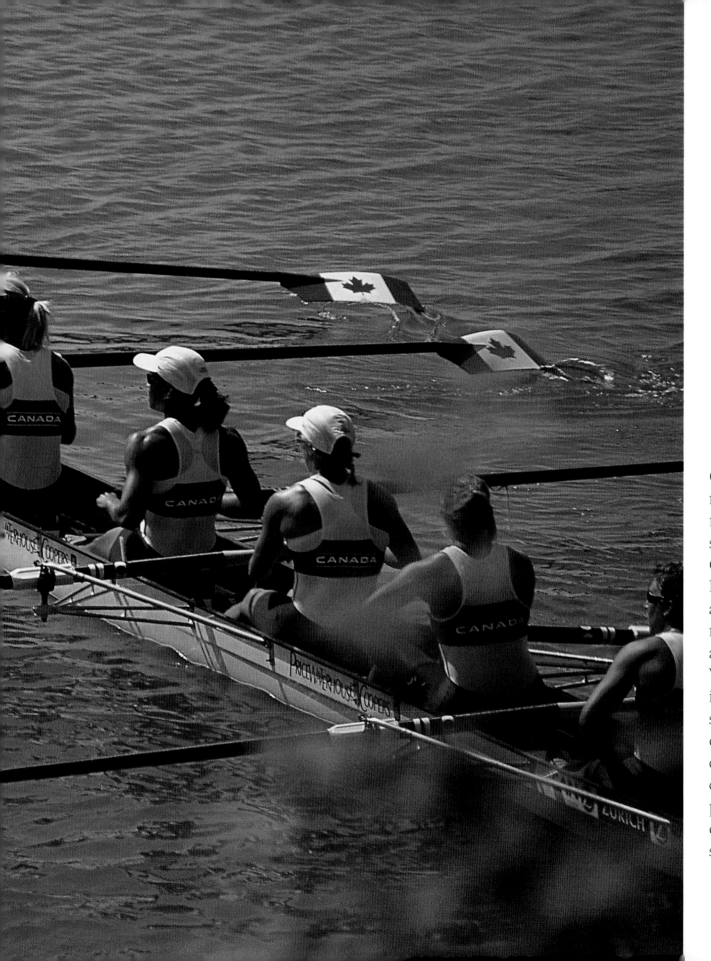

One of the continent's most popular rowing competitions since 1903, the Royal Canadian Henley Regatta in St. Catharines now draws more than 2,000 athletes each August. When women's rowing was first demonstrated in 1947, a doctor followed closely behind, in case the "delicate" participants were overcome by the stress of the event.

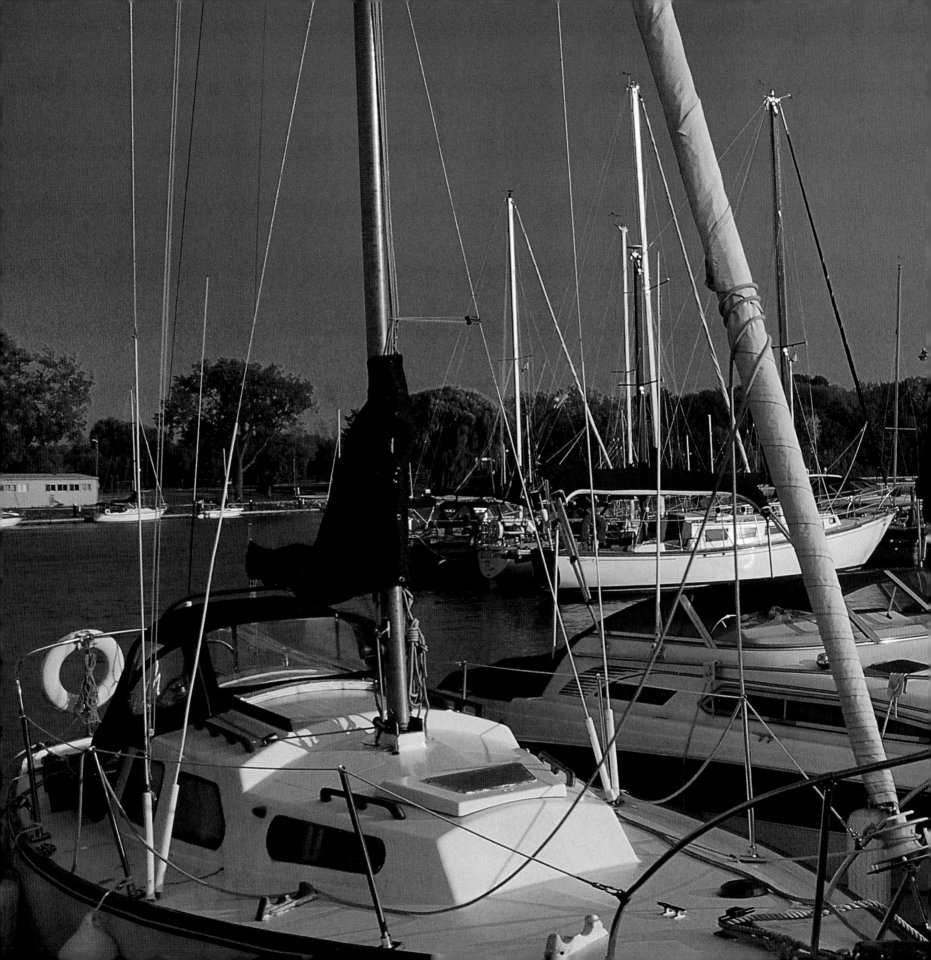

Fishing and sailing enthusiasts take to the waters of Lake Ontario from the St. Catharines Marina. Almost 200 floating docks at the marina cater both to privately owned vessels and charter tour boats.

Known as Ontario's Garden City, St. Catharines boasts a bird
sanctuary, botanical gardens, a rose garden with more than
1,300 plants, and the popular Lakeside Park, where families
and visitors retreat for picnics and strolls along the beach.

The Bruce Trail follows the Niagara Escarpment for more than 800 kilometres (500 miles) between Niagara Falls and the small town of Tobermory. The trail was officially opened in 1967 after years of work by local landowners and volunteers.

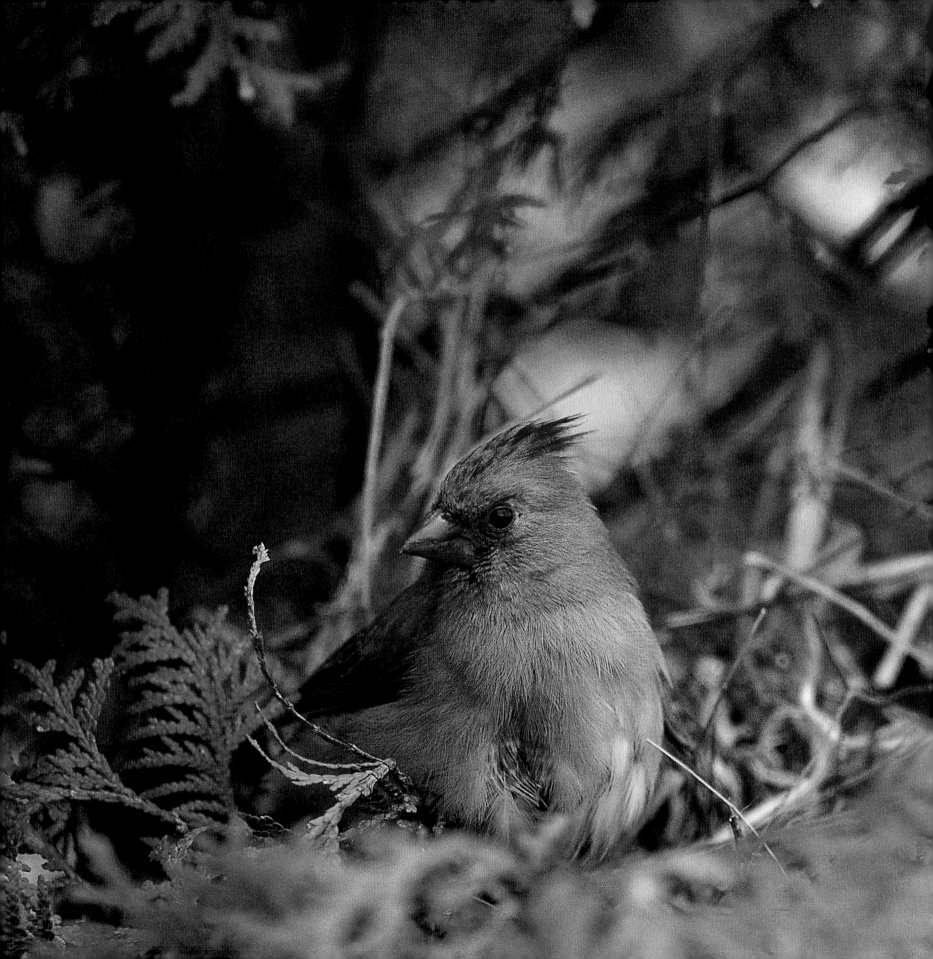

The Niagara Escarpment is a heavily forested corridor that passes through the most heavily developed area in Canada. It affords refuge for wildlife such as this northern cardinal, and has been designated a World Biosphere Reserve by UNESCO.

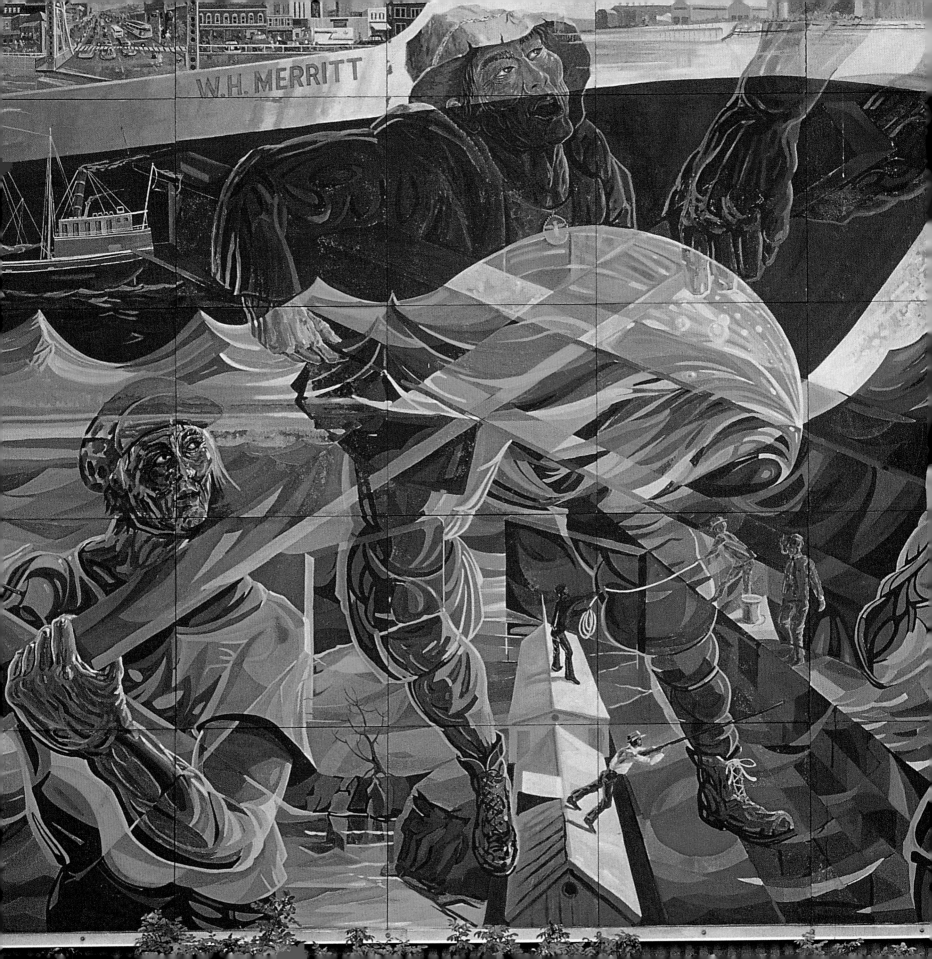

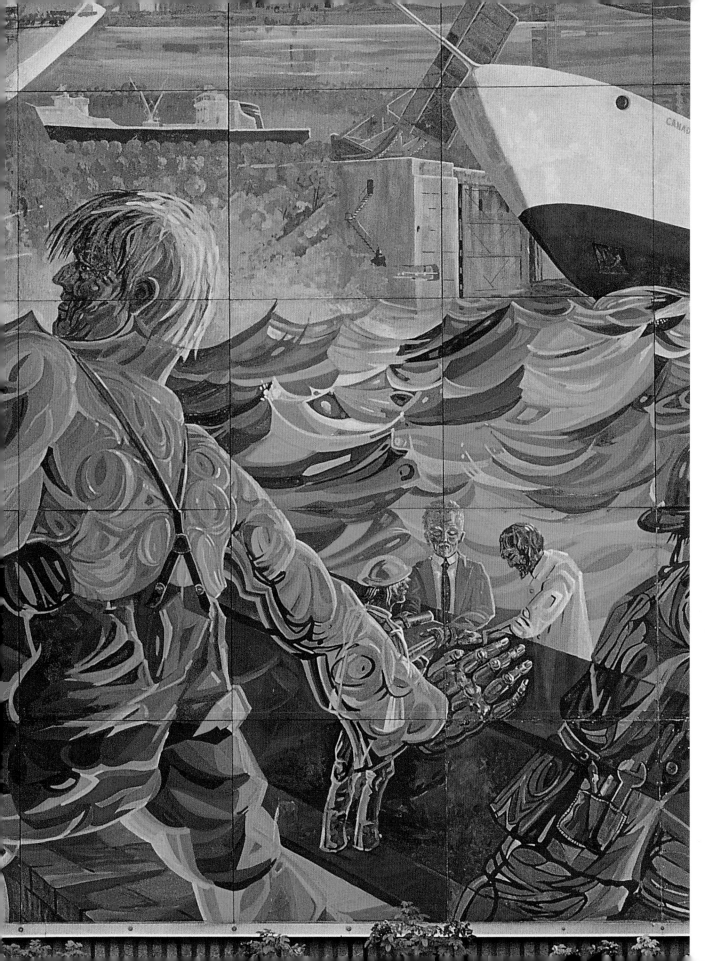

Since 1986, Welland has invited artists from around the world to create giant murals, some reaching three stories high. There are now more than 25 murals, each depicting a different scene from Welland's rich history.

In the early 1800s, businessman William Hamilton Merritt established the Welland Canal Company, so that goods could be shipped along an entirely Canadian route. The canal was completed in 1829.

Eight locks in the Welland Canal lift ships 99 metres (325 feet) on the voyage between Lake Ontario and Lake Erie. They are capable of lifting vessels that weigh more than 30,000 tonnes (tons) and are longer than two football fields.

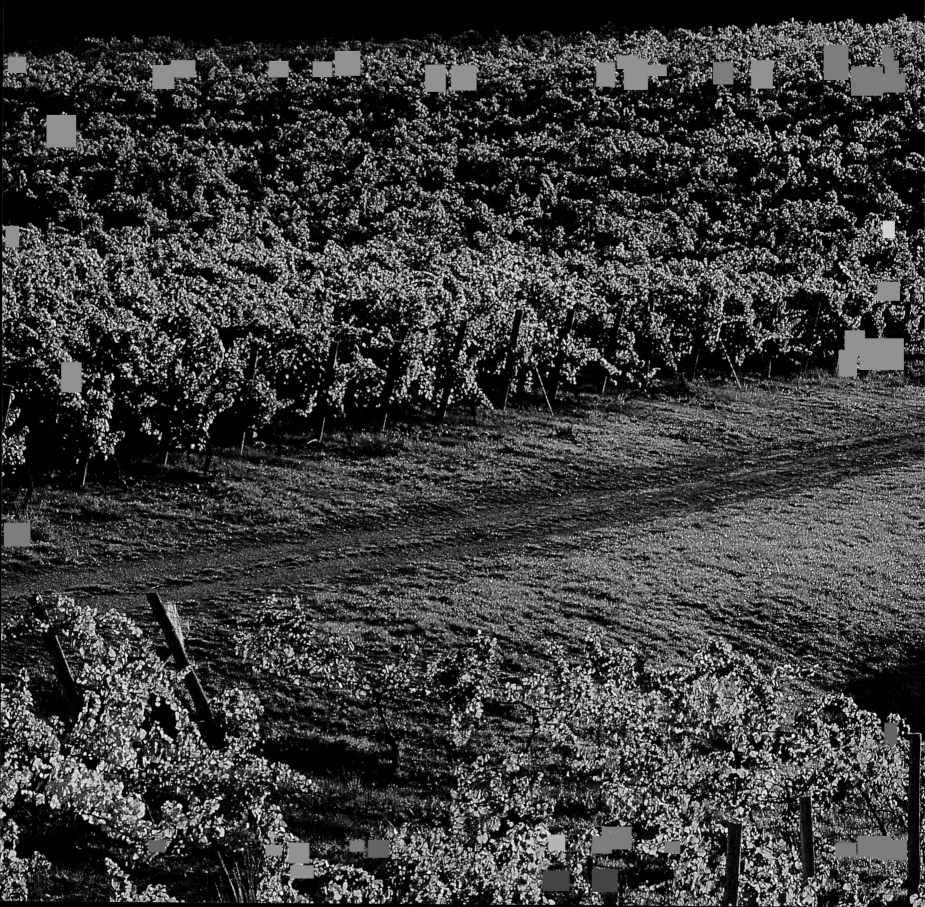

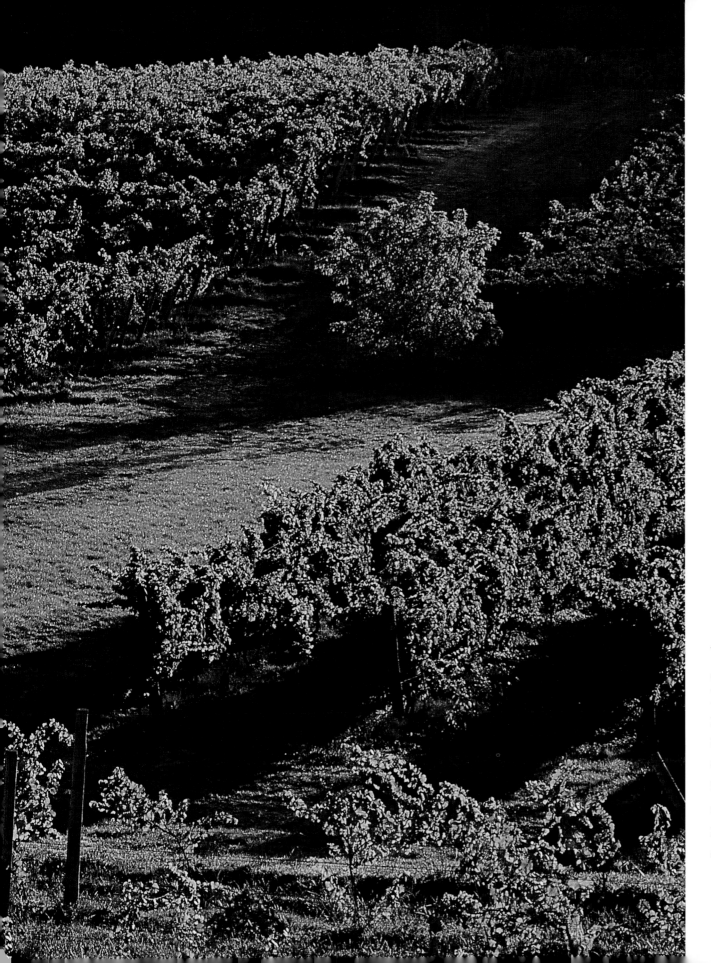

Wine lovers who drop into the Vineland Estate Winery may take a winery tour, sneak previews of upcoming vintages, attend cooking classes, or sample regional fare at the estate's restaurant.

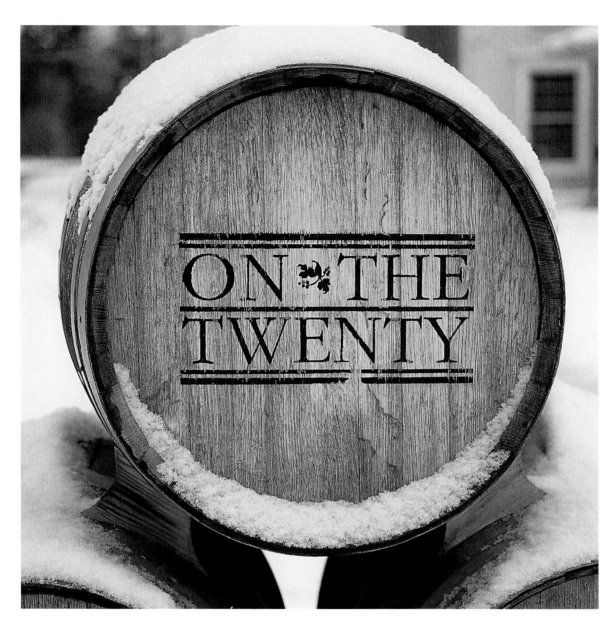

Foie Gras Ice Wine Pâté in Brioche, Shorthills Trout with Riesling Rhubarb Butter, Stone Edge Farm Partridge, and Espresso Chocolate Torte—these are just some of the dishes on the menu at On the Twenty.

On the Twenty was Ontario's first estate winery restaurant. Considered one of the best in the region, and one of the province's most famous, the restaurant offers seasonal and regional fare along with wines from the Cave Spring Cellars.

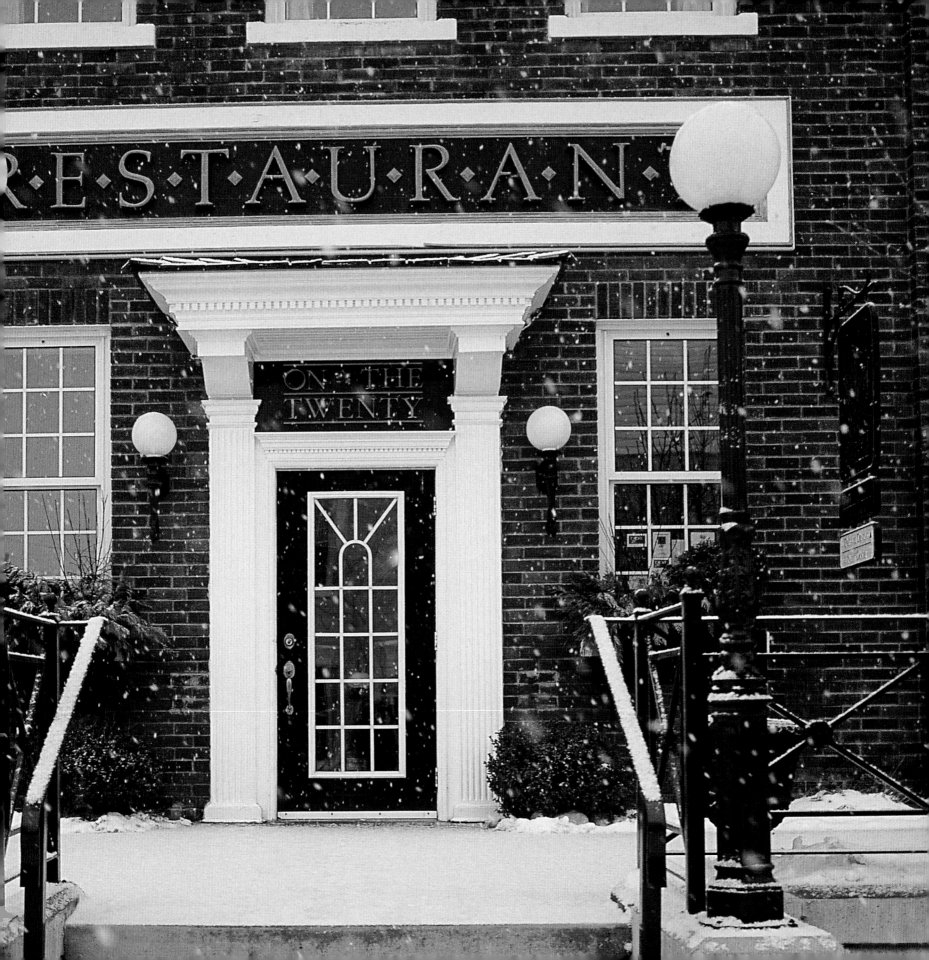

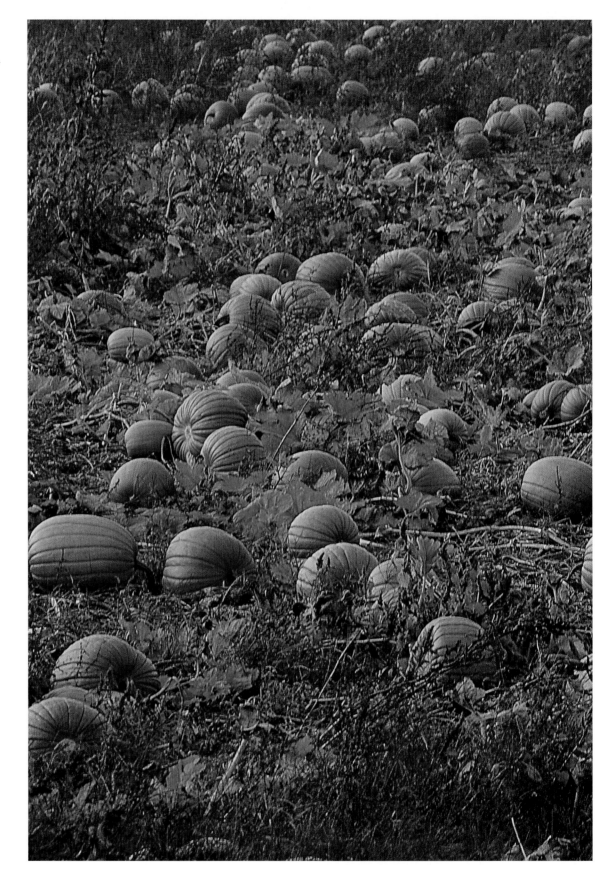

The area surrounding the falls is equally lush in both Canada and the United States. In the New York county of Eastern Niagara, agriculture is central to the economy. The county produces $46 million U.S. of agricultural sales each year, mainly in fruit, grain, and vegetables.

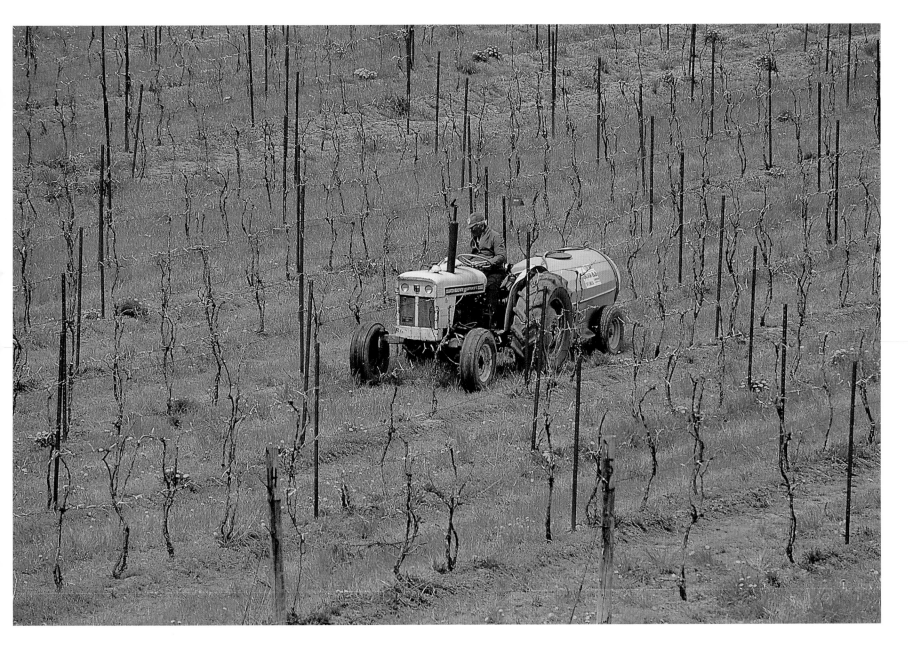

With more than 100 events, the Niagara Grape and Wine Festival each fall features parades, regional cuisine, children's programs, live concerts, and, of course, wine tastings. The region has now celebrated the annual grape harvest for half a century.

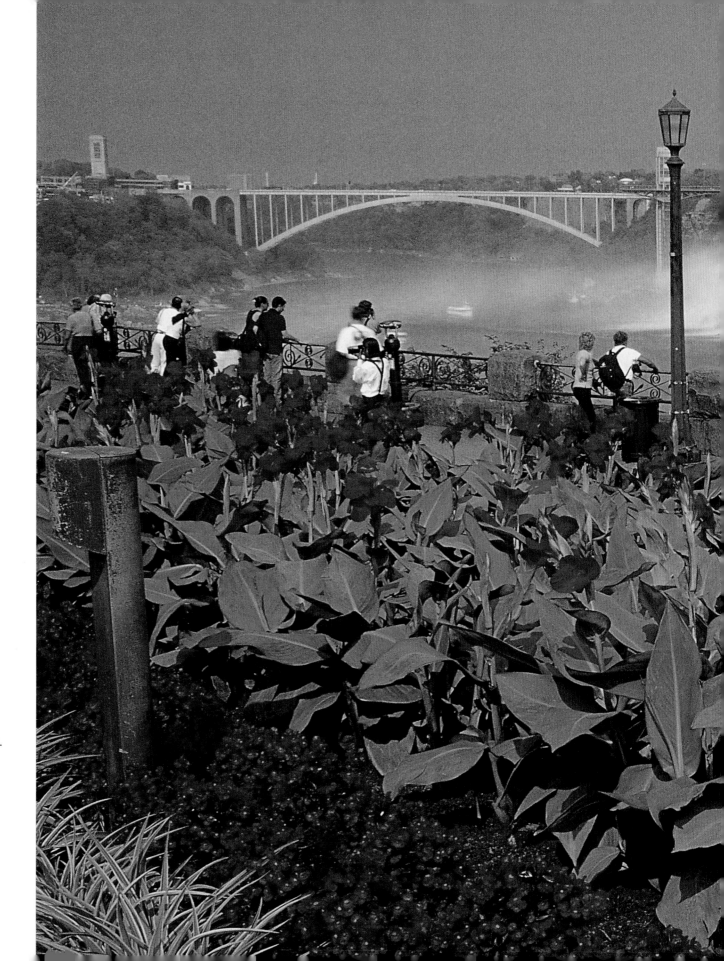

The first person
to survive the trip
over Niagara Falls
encased in a barrel
was a 63-year-old
schoolteacher
named Annie Taylor.
Strapped into a
special harness,
her 17-minute trip
gained her long-
lasting fame.

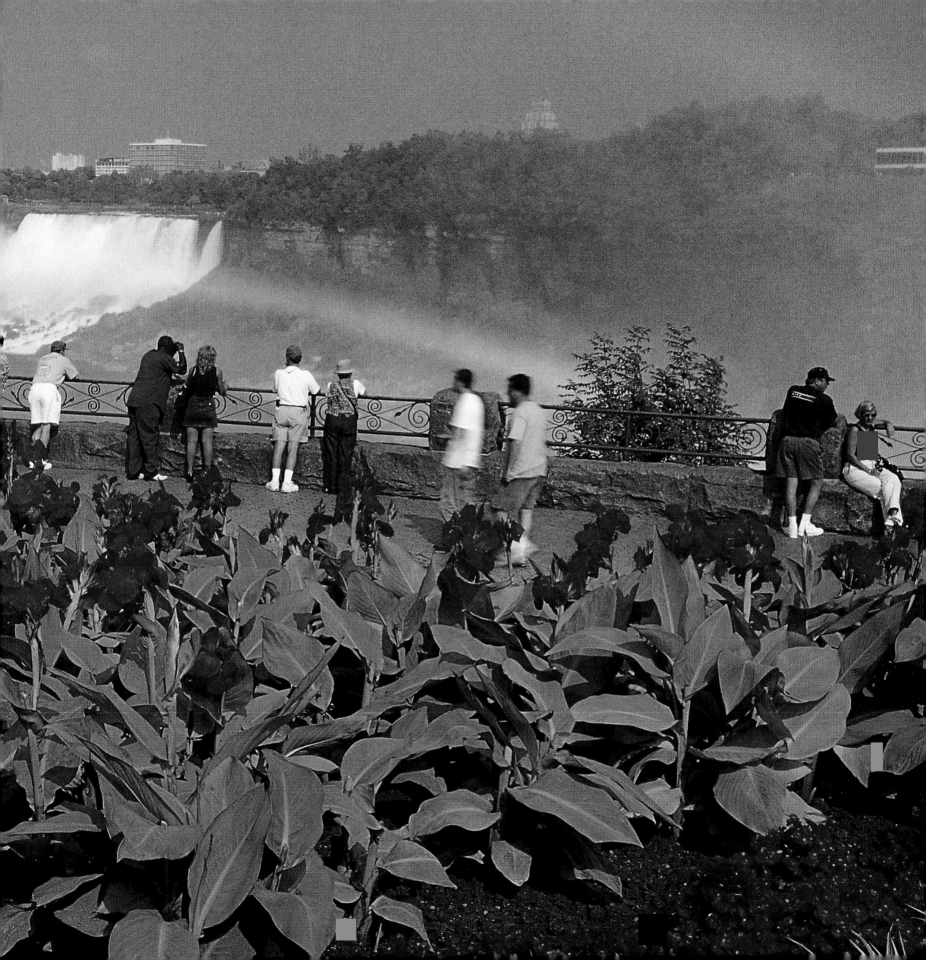

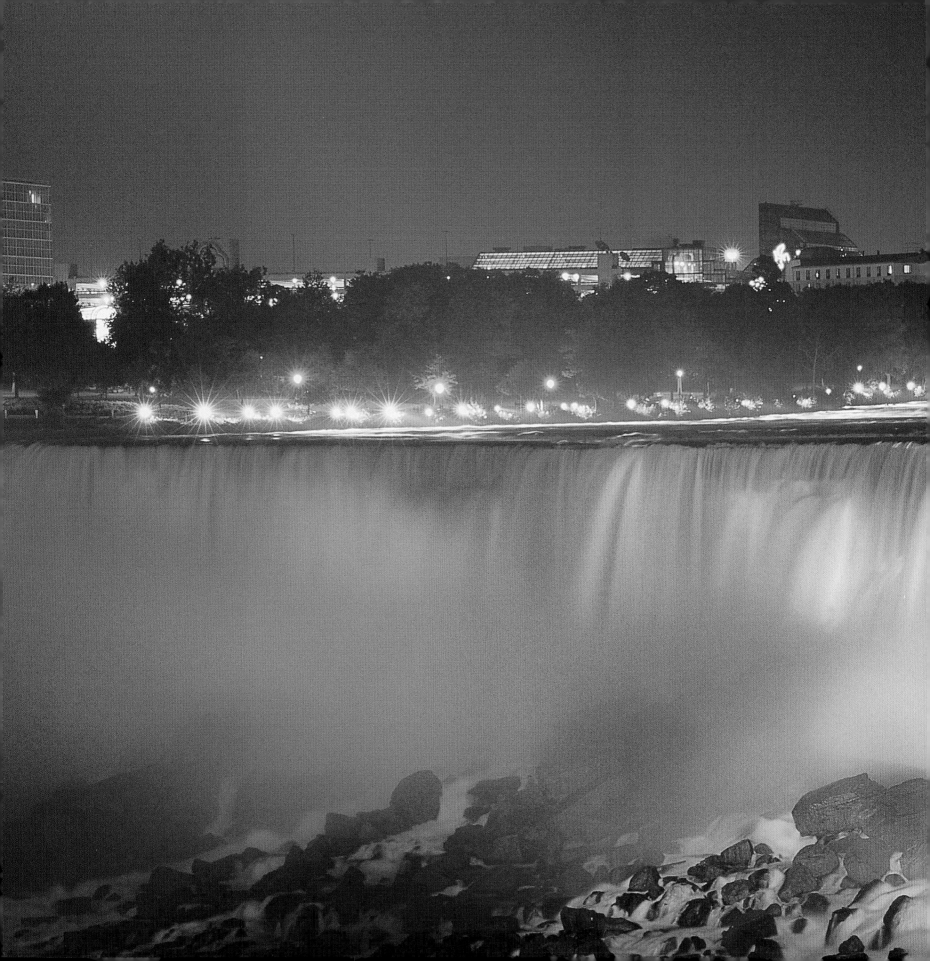

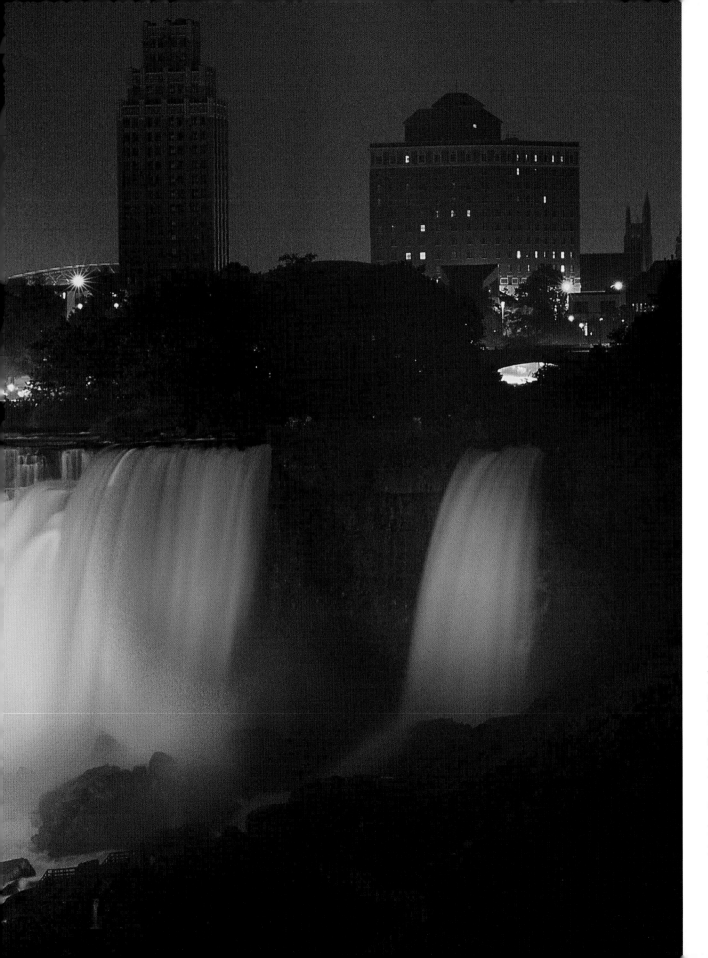

It has taken the Niagara River 12,000 years to create the dramatic rock shelf between lakes Erie and Ontario. Each night, 21 lights, 76 centimetres (30 inches) in diameter, illuminate the river's achievement.

93

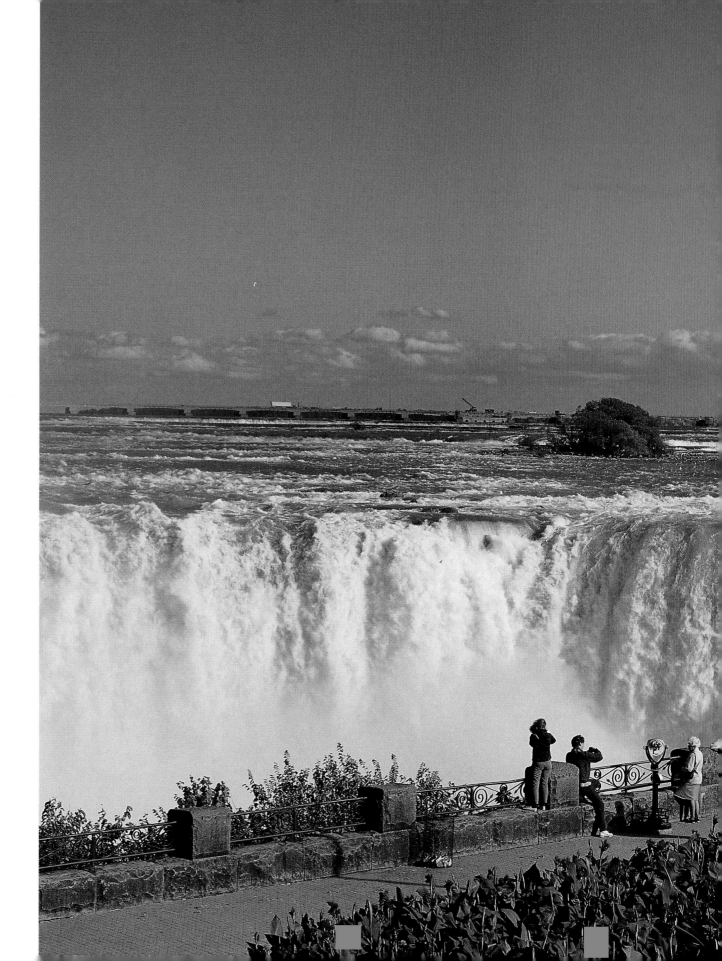

The river's power
has been harnessed
for hydroelectricity
since 1893. Today,
power plants on
both the American
and Canadian sides
produce enough
electricity to
light 24 million
100-watt bulbs.

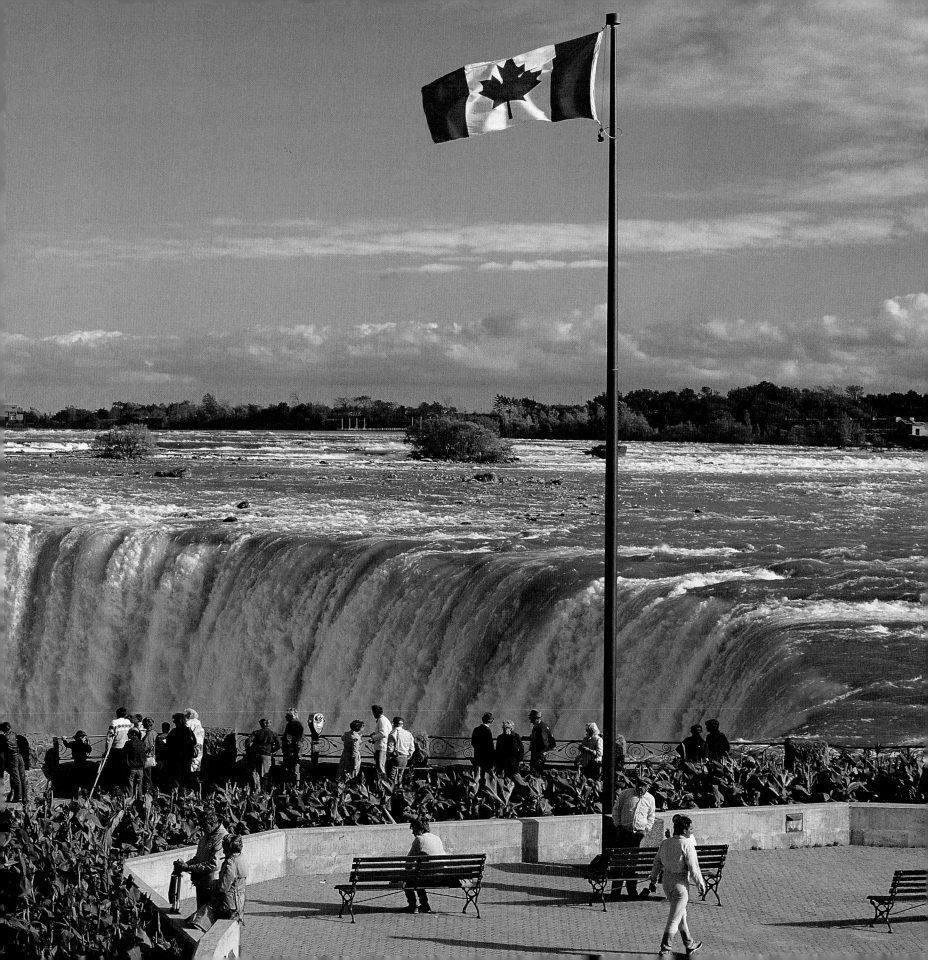

Photo Credits